D1635348

AN ABSOLUTE TURKEY

Georges Feydeau

AN ABSOLUTE TURKEY

translated from *Le Dindon*

by Nicki Frei and Peter Hall

OBERON BOOKS
LONDON

First published in 1994 by Absolute Classics
Reprinted in 2000 in this edition by Oberon Books Ltd.
(incorporating Absolute Classics)
521 Caledonian Road, London N7 9RH
Tel: 0171 607 3637 / Fax: 0171 607 3629
e-mail: oberon.books@btinternet.com

A catalogue record for this book is available from the British
Library.

ISBN 0 948230 74 6

Cover design: Andrzej Klimowski

Typography: Richard Doust

Printed in Great Britain by Antony Rowe Ltd, Reading.

Laughing until it hurts

Peter Hall

The British have long been wary of Georges Feydeau, the uncompromising master of French farce. He lived from 1885 until 1921 and wrote a succession of boulevard plays which in their wild, comic energy verge on the surreal.

His subject is sexual attraction – or, to put it more plainly, lust, and the insanities it produces. This seemed a little improper to British audiences of the early part of this century used, as they were, to the amiable farces of Pinero or the innocent Alice-In-Wonderland of Ben Travers. We have grown more broad-minded since, and our unease with Feydeau has diminished as we have learnt to appreciate his ruthlessness.

Feydeau observed, "When two of my characters should under no circumstances encounter one another I throw them together as quicky as possible". He recorded the behaviour of human beings in a clinical and very un-British way. His characters are monstrous, and if we excuse them with understatement or sweeten then with devious Anglo-Saxon charm, the accuracy of the observation is blunted and a great deal of the comedy disappears. His plays are crammed with frantic self-obsessed people who pursue their desires with no regard for each other's feelings and little respect for integrity, honesty or decency. It is all just like real life, Feydeau would doubtless have said. Certainly without laughter, it could be a harsh experience. Like many comics, Feydeau seems to have been a serious man. He makes us laugh, but he did not amuse himself: "I never laugh in a theatre. I seldom laugh in my private life," he said.

His plays were written as commercial entertainments, but they nonetheless demonstrate a keen moral sense, always ready to judge the awfulness of human behaviour. Perhaps that is why they still merit attention: it is not enough for comedy to be simply funny. His plays are full of well-deserved punishments

as the characters get their come-uppance for their various misdemeanours. The obsessive seducer finds that his over-ambitious appetite has made him incapable of making love. The compulsive flirt is summarily rejected. The hypocrisy of a very self-important age is exposed as Feydeau strips men and women to their essential appetites. Every character is an animal alone in the bourgeois jungle, isolated by selfishness and turning predator in order to survive. It is an unblinking and very French view of human behaviour.

Feydeau satisfies the somewhat reprehensible pleasure we take in watching others suffer. His talent is aggressive and unrelenting. We do not sympathise with his characters; we watch them dispassionately as they thrash around *in extremis.* Marcel Achard notes that "we are occasionally given some respite by the heroes of Shakespeare and Racine, when they melodiously bewail their fate in beautiful poetry. But Feydeau's heroes haven't got time to complain…"

In the closed and secret rooms of Feydeau's farces, with the audiences as the hidden onlookers, the characters do great hurt to each other. The door can be locked or double-locked, and bolts can always be shot. The door is indeed the dramatic tool of these farces; it enables characters to encounter each other; it protects and hides them when it is shut and reveals them when it is unexpectedly opened. We never know who is coming in next.

Feydeau deals not in understatement but overstatement. His plays are long on the page – a riot of words that qualify and justify the nightmares his characters are in, but they play fast as the words are used to hold desperation at bay and hide insecurities. Every person is sooner or later in a terrible crisis, and the only way out is a fever of words. There is not time to think; only to speak. No character in Feydeau speaks slowly: the pressure on him makes it impossible.

British actors know just how frantic they have to be, thanks to the example of the great French actor and director, Jacques Charon. He showed us how to act Feydeau at Olivier's National Theatre in the 60s with his production of *A Flea in Her Ear.*

And Feydeau worked fully in English for the first time. Audiences laughed until it hurt, but then realised what they had been contemplating: unmentionable behaviour which they were quite capable of committing themselves.

The plots of Feydeau's plays are great symphonic structures of intrigues, betrayals, mistakes and misunderstandings. The coincidences are sometimes described as mechanical but this is unfair. *Le Dindon* (translated as *An Absolute Turkey*) is the most elegantly complex of his plays. By the end of each act, every character is spinning dizzily in a surrealistic climax of complications – caught in a nightmare played at double speed. They are uncomfortably truthful, filled with the hideous parallels of real life – or rather those disquieting moments when life becomes so pressurised that it seems like a bad dream.

His language is demented too: each character dare not stop talking as he runs away from his pursuers. His dialogue is in no sense good French: the pressure put on the words by the situations does not allow it. Claude Berton described the style brilliantly: "It is chopped up, chaotic, slangy, elliptical, stuffed with a jumble of mad preposterous ideas, like the coat of a conjurer whose sleeves are full of fish, flowers, omelettes, bars of soap and cannon balls". It is truly the language of people at the end of their tether. It should also remind us that Feydeau and Strindberg – both possessed men – were contemporaries.

Feydeau is not easy to translate. Although he writes colloquial French, the rhythm is often almost as important as the meaning. So in translation the right rhythm produces the laugh, but the misplaced word kills it. Nicki Frei and I had much sweat and joy in trying to find English equivalents, and we were greatly helped by the taste and inventiveness of our cast as they rehearsed. The text is therefore for acting rather than reading. It is also for acting fast (and much faster than any actor will initially think). There are also a large number of small cuts made from the experience of playing to audiences in London in 1994.

Great farce is always nurtured by a society constrained by taboo. Feydeau's bourgeoisie pretended to be respectable but

underneath were extraordinarily licentious. Perhaps our time is too unbuttoned to make farce easy; but we can still enjoy the lessons of the past. Farce is a very serious business; the hypocrisy of human behaviour is always its subject and we learn as much by laughing as by crying.

Peter Hall
January 1994

Characters

LUCIENNE *Caryl*
PONTAGNAC *Shackley*
VATELIN *Hugh*
JEAN *Emily B*
REDILLON *Dan*
MME PONTAGNAC *Emily E.*
MITZI *Nodenie*
SOLDIGNAC *Leighton*
ARMANDINE *Ria*
VICTOR *Ben*
HOTEL MANAGER
CLARA *Kat*
PINCHARD *Andrew*
MME PINCHARD *Emily B*
HOTEL GUESTS
INSPECTOR
SECOND INSPECTOR
OFFICERS
GEROME
POLICEMEN

This translation of *An Absolute Turkey* was first performed at the Globe Theatre, London in January 1994. The cast in order of appearance was as follows:

LUCIENNE, Felicity Kendal

PONTAGNAC, Nicholas Le Provost

VATELIN, Geoffrey Hutchings

JEAN, HOTEL GUEST, POLICEMAN, Adam Maxwell

REDILLON, Griff Rhys Jones

MADAME PONTAGNAC, Caroline Loncq

MITZI, Rosie Timpson

SOLDIGNAC, Olivier Pierre

ARMANDINE, Dervla Kirwan

VICTOR, Richard Henders

HOTEL MANAGER, GEROME, Ken Wynne

CLARA, Susie Brann

PINCHARD, Peter Cellier

MADAME PINCHARD, Linda Spurrier

HOTEL GUEST, SECOND INSPECTOR, Keith Morris

HOTEL GUEST, Lisa Marks

HOTEL GUEST, Caroline Fenton

INSPECTOR, Paul Stewart

Director, Peter Hall

Designer, Gerald Scarfe

Lighting Designer, Joe Atkins

Costume Consultant, Steven Gregory

Assistant Director, Gillian Diamond

Movement Supervisor, Terry King

Set Design Assistant, Mike Bailey

Costume Assistant, Vivienne Jones

The translators would like to thank the cast for their many contributions to the real playing version.

ACT ONE

Scene 1

Paris: the drawing room of VATELIN's house.

As the curtain rises, the stage is empty. Voices are heard offstage. LUCIENNE, in outdoor clothes and with her hat slightly askew, bursts into the room, looking panic-stricken.

LUCIENNE, PONTAGNAC.

LUCIENNE: (*Rushing in, closing the door behind her. She is not quick enough to prevent a walking-stick being thrust in the door as she closes it.*) My God!

PONTAGNAC: (*Offstage.*) Madame! Madame!

LUCIENNE: Go away, Monsieur! Go away…!

PONTAGNAC: (*Pushing open the door each time that LUCIENNE closes it.*) Madame…! Madame…! If you'd just allow me…!

LUCIENNE: I'll do no such thing! I've never known such behaviour! (*Shouting while she struggles with the door.*) Jean! Jean! Augustine! (*Aside.*) Oh my God, there's nobody here!

PONTAGNAC: Madame! Please allow me!

LUCIENNE: No! No!

PONTAGNAC forces his way in.

PONTAGNAC: I beg you Madame just to listen to me.

LUCIENNE: This is outrageous! I forbid it! Absolutely. Get out, Monsieur!

PONTAGNAC: There's no reason to be afraid, Madame. I don't wish you any harm! My intentions

11

may not be pure, but I swear they're not hostile. Quite the contrary in fact. (*He goes towards her.*)

LUCIENNE: (*Drawing back.*) I think you're mad!

PONTAGNAC: (*Following her.*) Yes, Madame, I am mad – mad for you! My behaviour is outrageous, but I don't care! I only know that I love you and I'd do anything to get you.

LUCIENNE: I can't listen to any more of this! Monsieur, leave my house!..

PONTAGNAC: I tell you I love you! (*He starts to pursue her again.*) One look and it was love at first sight! I have dogged your footsteps for an entire week. Haven't you noticed?

LUCIENNE: What? No, as a matter of fact I haven't.

PONTAGNAC: You have. You know you have. A lady always notices when she's being followed!

LUCIENNE: God, what arrogance!

PONTAGNAC: It's not arrogance. It's personal experience.

LUCIENNE: Whatever it is, Monsieur, I don't know you!

PONTAGNAC: And I don't know you. It makes me miserable, Madame. I can't allow it to continue.

LUCIENNE: Monsieur!

PONTAGNAC: Oh, Marguerite!

LUCIENNE: (*Forgetting herself.*) My name is Lucienne.

PONTAGNAC: Thank you. Oh, Lucienne!

LUCIENNE: What! How dare you!

PONTAGNAC: But you just told me your name!

LUCIENNE: Really, Monsieur, what do you take me for? I am a respectable woman!

PONTAGNAC: Oh good, I adore respectable women!

LUCIENNE: Be careful, Monsieur! I hoped to avoid a scene, but if you won't leave, I shall have to call my husband!

PONTAGNAC: What! You have a husband?

LUCIENNE: I certainly have!

PONTAGNAC: Well, never mind him. Let's forget the old fool.

LUCIENNE: My husband is a fool?

PONTAGNAC: Attractive women always have husbands who are fools.

LUCIENNE: Very well. Let's see how the fool deals with you! You don't wish to leave?

PONTAGNAC. Less with every moment!

LUCIENNE: Very well! (*Calling out.*) Crépin!

PONTAGNAC: (*Aside.*) What a revolting name!

LUCIENNE: Crépin!

Scene 2

LUCIENNE, PONTAGNAC, VATELIN.

VATELIN: (*Entering.*) Did you call, my dear?

PONTAGNAC: (*Aside.*) Vatelin! Damn!

VATELIN: (*Aside, recognising PONTAGNAC.*) Good heavens! It's Pontagnac! (*To PONTAGNAC.*) My dear friend!

LUCIENNE: (*Aside.*) What!

PONTAGNAC: Vatelin, my dear fellow!

VATELIN: Are you well?

PONTAGNAC: Yes, very well!

LUCIENNE: (*Aside.*) He knows him!

PONTAGNAC: Well, this is a surprise!

VATELIN: Is it? This is my house, who else did you expect to find here?

PONTAGNAC: Eh? No. I meant what a surprise I must have given you.

VATELIN: Oh, I see. Yes, you certainly have!

LUCIENNE: Oh, yes you certainly have! (*To VATELIN.*) You mean you know this gentleman?

VATELIN: Of course I know him!

PONTAGNAC: Yes. Yes. He, we're… (*Losing his head, he takes a coin out of his pocket and presses it in LUCIENNE's hand.*) Look, why don't you take this? And not a word, not a word!

LUCIENNE: (*Aside, stunned.*) He's given me a tip!

VATELIN: (*Who has noticed nothing.*) What's the matter with you?

PONTAGNAC: Me? Nothing's the matter with me. Why should anything be the matter with me?

LUCIENNE: (*Quietly.*) Take it back, Monsieur. What do you expect me to do with this money?

PONTAGNAC: Oh, I beg your pardon, Madame! (*Aside.*) I don't know what I'm doing. I'm losing my head.

VATELIN: My dear chap! You can't imagine how happy I am. You've promised to come so often and at last you're here.

LUCIENNE: Yes, at last you're here.

PONTAGNAC: Oh, you're too kind, both of you! Too kind. (*Aside.*) I think she's making fun of me!

VATELIN: But I don't believe you know my wife. (*Introducing her.*) My dear, one of my best friends, Monsieur Pontagnac. My wife.

PONTAGNAC: Madame!

VATELIN: Actually, I don't think I'm being very clever, introducing you to Pontagnac.

LUCIENNE: Why is that?

VATELIN: Oh he's a monster! You don't know him. He can't look at a woman without running after her. He wants them all.

LUCIENNE: (*Mockingly.*) Wants them all? Well, that's not very flattering to any of them.

PONTAGNAC: Oh, Madame, he's exaggerating! (*Aside.*) What a fool to tell her that!

LUCIENNE: How dreadful for the poor woman who thinks she's special to find that she's only one of a crowd.

PONTAGNAC: I tell you, Madame, it is quite untrue.

LUCIENNE: Well, I tell you I wouldn't care for it. Won't you sit down?

PONTAGNAC: (*Aside.*) Yes, she's making fun of me.

VATELIN: (*Sitting next to him, genially.*) I must say, I don't think she approves of you.

PONTAGNAC: I don't think she does!

LUCIENNE: It is clear, gentlemen, that you have a very low opinion of women – judging by the way

you treat us. The man who woos graciously is a gentleman. He is at least putting on a show of respect. But the man who seduces by brute force, who begins perhaps by following us in the street…

PONTAGNAC: (*Aside.*) Here we go! Here we go!

VATELIN: Now, come on! Who follows women in the street? Gigolos, lunatics, and dirty old men.

LUCIENNE: (*Sweetly to PONTAGNAC.*) Which would you prefer?

PONTAGNAC: (*Embarrassed.*) I don't know why you're asking me…

VATELIN: My wife was speaking in general.

LUCIENNE: Of course I was.

PONTAGNAC: Oh good! (*Aside.*) I don't know how we got into this conversation.

LUCIENNE: Well, if I were a man, I'd have no taste for violent conquest.

PONTAGNAC: (*Embarrassed.*) I agree. You're absolutely right! (*Aside.*) How long is she going to keep this up?

LUCIENNE: But not all men think like you – if the man who has been following me is anything to go by!

PONTAGNAC: (*Aside.*) Now she's gone too far!

VATELIN: A man has been following you?

LUCIENNE: For nearly a week!

PONTAGNAC: (*Getting up.*) Look, why don't we talk about something else? I think that this conversation is –

VATELIN: (*Interrupting.*) No, no! This is interesting. Can you believe that a man would dare to follow my wife?

PONTAGNAC: Yes. But oh, so discreetly!

VATELIN: How would you know? (*To LUCIENNE.*) Why didn't you tell me before?

LUCIENNE: Why should I? It was nothing. He wasn't remotely dangerous.

PONTAGNAC: (*Aside.*) Thank you very much.

VATELIN: You should have tried to get rid of him. It must be very tiresome for you to have someone following you around.

LUCIENNE: Oh, very tiresome!

VATELIN: Besides which, it's humiliating for me. (*To PONTAGNAC.*) My dear friend, would you believe there are such people in Paris? If a husband – a lawyer too – can't let his wife go out without exposing her to the impertinent advances of a gross, dirty minded…

PONTAGNAC: (*Furious.*) Vatelin!

VATELIN: Yes?

PONTAGNAC. Now you've gone too far!

VATELIN: Nonsense! I'd love to get my hands on the nasty little rat!

LUCIENNE: Oh good! Well that's easy isn't it, Monsieur Pontagnac?

PONTAGNAC: Is it?… Oh God! Er, what time is it?

VATELIN: What! You mean he knows him?

LUCIENNE: Better than anyone. Won't you tell us his name?

PONTAGNAC: Madame, are you serious?

LUCIENNE: Of course. He's called Pon…ta… Pont…ta… what is it now? Ponta what?

PONTAGNAC: Ponta*what*! Yes, that's it.

LUCIENNE: (*Correcting him.*) Pontagnac!

VATELIN: Pontagnac! You!

PONTAGNAC: (*With a forced laugh.*) Yes, it was me…! Ha, ha, ha! It was me!

VATELIN: (*Bursting into laughter.*) Ah! Ah! Ah! You old rascal!

PONTAGNAC: Of course I knew all the time. I knew she was Madame Vatelin. So I said to myself, 'I'll tease her a bit. I'll pretend to follow her…'

LUCIENNE: (*Aside.*) Pretend to follow…!

PONTAGNAC: It'll give her such a surprise the day she comes face to face with me in her husband's house.

VATELIN: Nonsense! You knew nothing of the sort! That'll teach you to follow women! You chose the wife of a friend and wasted your time. Let it be a lesson to you.

PONTAGNAC: All right! I'll own up. You don't bear a grudge, do you?

VATELIN: Me? Of course not! At the end of the day, I know you're still my friend. What annoys me – because I have complete confidence in my wife – is if I'm made to look a fool. That's all I care about. I mean, a man follows my wife, and I say to myself, 'I wonder if he knows who she is'. Then he meets me and thinks: 'Hang on, this is the husband of the lady I've been following'. It makes me look a bit of a fool. But you, you know who I am already, don't you? I know that you know, you know that I know that you know. We know that we know that we know! So it doesn't bother me. I don't look a fool at all.

PONTAGNAC: Quite!

VATELIN: If anyone does, it's you!

PONTAGNAC: Me!

VATELIN: Of course. It's always annoying to make a fool of yourself.

PONTAGNAC: Not in this case. I've once more had the pleasure of meeting you.

VATELIN: The pleasure's mutual I assure you!

PONTAGNAC: You're too kind!

VATELIN: Not at all!

LUCIENNE: (*Aside.*) How touching! (*Aloud.*) I'm delighted to have brought you two together.

VATELIN: There's just one thing. You must apologise to my wife.

PONTAGNAC: (*To LUCIENNE.*) Ah Madame, I am very much to blame!

LUCIENNE: I'm afraid you're all the same, you bachelors.

VATELIN: He's not a bachelor. He's a married man.

LUCIENNE: No!

VATELIN: Oh, yes!

LUCIENNE: Married! You're married?

PONTAGNAC: (*Embarrassed.*) Yes. In a manner of speaking.

LUCIENNE: But that's outrageous!

PONTAGNAC: You think so?

LUCIENNE: It's appalling! How did it happen?

PONTAGNAC: Oh well, you know how it is! One fine day, you find yourself at the Town Hall, you're not

sure why. Circumstances beyond your control. They ask you questions. You reply 'yes' like that because well… there are people about. Then, when everybody's cleared off, you find that you're married. And for life.

LUCIENNE: Really, Monsieur, you are without shame.

PONTAGNAC: For being married?

LUCIENNE: No. For carrying on as you do when you are married. What does Madame Pontagnac say about your conduct?

PONTAGNAC: To tell the truth, I don't keep her informed.

LUCIENNE: How charming! And do you think that's an honourable way to behave?

PONTAGNAC: Well… I…

LUCIENNE: I'd like to know what you'd say if your wife did the same.

PONTAGNAC: Oh, that's quite different!

LUCIENNE: Of course. Quite different! That's what men always say. Your wife should have a little flutter just to see how you like it.

VATELIN: Now steady on Lucienne! Pontagnac won't like you if you go on lecturing him.

LUCIENNE: Oh, I'm not just talking to him. It applies to you too.

VATELIN: Me? Oh!

LUCIENNE: You'd be well advised not to follow in his footsteps. It wouldn't take much. I'd be off in a minute.

PONTAGNAC: (*Barely disguising his pleasure.*) Really?

VATELIN: Why are you looking so pleased?

PONTAGNAC: Me? I'm not.

LUCIENNE: I don't know your wife, but I feel sorry for her.

PONTAGNAC: I know, Madame. I'm never unfaithful without feeling sorry for her too!

LUCIENNE: You must feel sorry for her very often.

VATELIN: (*Cheerfully changing the subject.*) Well, now you know the way, I hope you'll bring Madame Pontagnac to our home. My wife and I will be delighted to meet her.

PONTAGNAC: (*Aside.*) My wife! Oh no! That would finish everything! (*Aloud.*) Why yes, of course. I would be very happy and so would she. Unfortunately, it's out of the question.

LUCIENNE: Why is that?

PONTAGNAC: Her rheumatism. She is crippled with rheumatism.

VATELIN: Really?

PONTAGNAC: She never goes out. Or when she does it's in a bathchair. There's a man who pulls her, Emile.

VATELIN: (*Confused.*) A mule?

PONTAGNAC: No, a man.

VATELIN: That's awful! I didn't know.

LUCIENNE: How very sad!

PONTAGNAC: Don't tell me!

VATELIN: What a shame! Oh, but we could go and visit her, if you'd allow it.

PONTAGNAC: Why, of course! Certainly!

VATELIN: Where does she live?

PONTAGNAC: Aix.

VATELIN: Aix?

PONTAGNAC: En-Provence.

VATELIN: Goodness. That's rather a long way!

PONTAGNAC: Well, what could I do? The sun was recommended for her health.

VATELIN: We'll just have to give up the idea.

LUCIENNE: We're so sorry.

Scene 3

LUCIENNE, PONTAGNAC, VATELIN, JEAN.

JEAN: (*Entering.*) Monsieur, it's an art dealer. He has a landscape for Monsieur.

VATELIN: Ah! My Corot! I bought a Corot yesterday!

PONTAGNAC: Really?

VATELIN: Six hundred francs!

PONTAGNAC: That's very little! Is it signed?

VATELIN: Yes, it's signed. It's signed 'Poitevin'. But the dealer assures me that the signature is a fake.

PONTAGNAC: Are you serious?

VATELIN: So I'll have 'Poitevin' removed and then I'll be left with a Corot. (*To JEAN.*) I'm just coming. Excuse me a moment. Then I'll show you my pictures. You're a man of taste. You can tell me what you think. (*He goes out stage right.*)

PONTAGNAC: Quite!

Scene 4

LUCIENNE, PONTAGNAC.

LUCIENNE: Won't you sit down?

PONTAGNAC: I don't frighten you any more?

LUCIENNE: Not at all. Tell me what were you hoping for when you pursued me with such ferocity?

PONTAGNAC: Good God! What every man hopes for when he follows a woman that he doesn't know.

LUCIENNE: You're very frank.

PONTAGNAC: Well, if I told you I followed you in order to hear your opinion of Voltaire, you probably wouldn't believe me.

LUCIENNE: You rather amuse me. It works for you sometimes, does it? Your little ploy? Are there really women who capitulate?

PONTAGNAC: Oh yes, there certainly are! 33.333 per cent.

LUCIENNE: Well this time you've been unlucky. You've met one of the 66.666.

PONTAGNAC: Please don't talk about it any more, Madame. I'm morose and I'm married. It's a curse to have a nature like mine. I have women in my blood.

LUCIENNE: Oh dear! But when you marry you have to settle for just one of them.

PONTAGNAC: My wife, yes of course! Actually she's a charming woman. But she's been charming for an awfully long time now. She's like a novel I know from cover to cover.

LUCIENNE: Really? It can't be easy to turn the pages.

PONTAGNAC: Why not?

LUCIENNE: Her rheumatism.

PONTAGNAC: (*Not understanding.*) Rheumatism? Since when?

LUCIENNE: You just told us.

PONTAGNAC: (*Quickly.*) Ah! My wife, yes, yes. In Aix.

LUCIENNE: En-Provence.

PONTAGNAC: Absolutely! Well, yes. Eh?

LUCIENNE: Yes.

PONTAGNAC: Oh! Come on!… And you tell me I have no excuse, when heaven puts such a divinely enchanting creature in my path –

LUCIENNE: (*Interrupting.*) Enough, Monsieur! That's quite enough! I thought you had made your apologies.

PONTAGNAC: Listen. Will you promise not to tell anyone what I'm about to say?

LUCIENNE: Not even my husband.

PONTAGNAC: I can't ask for more. Well, I can't believe you really love him.

LUCIENNE: You're impertinent! Please move.

PONTAGNAC moves closer to her.

LUCIENNE: No. Move away!

PONTAGNAC: I beg your pardon. Of course, he's an excellent fellow! I like him very much.

LUCIENNE: I saw that immediately.

PONTAGNAC: But, just between ourselves, he's not a man to inspire passion.

LUCIENNE: He's my husband!

PONTAGNAC: There you are, you see. You agree with me.

LUCIENNE: No I don't!

PONTAGNAC: Oh yes you do! If you loved him, I mean really loved him – I'm not talking about affection – you wouldn't need to provide a reason for your love. A woman who loves, says 'I love because I love'. She doesn't say 'I love because he's my husband.' Being a husband proves nothing. Anyone can be a husband. If you are physically and mentally sound, any family will take you on. The only skills you need are those of a junior manager. Much more is needed of a lover. You need passion. You are the artist of love. The husband is merely the pen-pusher.

LUCIENNE: And you come here as the artist of love?

PONTAGNAC: Oh yes I do, I do.

LUCIENNE: Oh no, my dear Monsieur, no! You may think I'm absurd but I am blessed with a husband who fulfils both your definitions. He is both pen pusher and artist.

PONTAGNAC: (*With admiration.*) That's rare!

LUCIENNE: So I don't need anyone else. And as long as he doesn't try to dispense his artistic abilities elsewhere…

PONTAGNAC: Oh really? And if he were to dispense...

LUCIENNE: His abilities elsewhere? Ah, that would be a different matter. I am a firm believer in revenge. I have told my husband I would punish any infidelity by pretending to take a lover myself. But I wouldn't actually pretend.

PONTAGNAC: Oh, I can't thank you enough!

LUCIENNE: Don't mention it! I would never be the first to act. But I would be the second. And immediately! I was saying as much recently to…

PONTAGNAC: To whom?

LUCIENNE: To one of my aunts. She was desperate to know if I would ever do such a thing.

PONTAGNAC: (*Incredulously.*) Was she? An aunt?

Scene 5

LUCIENNE, PONTAGNAC, JEAN, REDILLON.

JEAN: (*Entering with REDILLION.*) Monsieur Rédillon.

LUCIENNE: Come in, my dear friend! Come in! You can help me. (*Making the introductions.*) Monsieur Ernest Rédillon, Monsieur Pontagnac, both friends of my husband. (*The two men greet one another.*) Now you know me well. Please explain to this gentleman that I am a model wife and would never be unfaithful to my husband unless he'd shown me the way.

REDILLON: What? I don't understand. Why are you asking me?

LUCIENNE: Please help me, this gentleman needs to know.

REDILLON: Gentleman? Oh, this gentleman! This must be a very intimate conversation. I wonder whether I'm not intruding.

LUCIENNE: You? Of course you're not. I'm asking for your help.

PONTAGNAC: Yes. We were only chatting.

REDILLON: Ah, were you really? You're no doubt an old, old friend. A close friend. Though I've never seen you in the house before.

LUCIENNE: This gentleman? I've only known him twenty minutes!

REDILLON: Better and better. Good Lord! Well, I'm sorry I can't answer your question. I have too much respect for women to discuss matters which I consider inappropriate – to me at least. So I am unable to give an opinion. I declare myself incompetent.

PONTAGNAC: (*Aside.*) I think he's trying to tell me something.

REDILLON: Your husband's not at home?

LUCIENNE: Oh yes! He's having a tête à tête with a Corot. I'll go and make sure he hasn't got lost in the landscape and bring him back here. I've introduced you, so now you know each other! I'll leave you together.

PONTAGNAC and REDILLON bow to one another. LUCIENNE goes out. A moment of silence while the two men secretly eye each other up.

PONTAGNAC: (*Aside.*) This must be the him. The auntie!

Scene 6

REDILLON, PONTAGNAC.

A silent scene; the two men go upstage and study the pictures on the wall They come slowly downstage, still looking at pictures, one on the right and the other on the left. From time to time they take a secret look at each other, but pretend indifference whenever their eyes meet. REDILLON reaches the sofa, slumps down and starts to hum.

PONTAGNAC: Did you say something?

REDILLON: I beg your pardon?

PONTAGNAC: I thought you were speaking to me.

REDILLON: No, I wasn't.

PONTAGNAC: Then I do beg your pardon.

REDILLON: Please don't mention it. (*He starts humming again.*) Da, da, dee, da!

PONTAGNAC: (*Irritated, begins to hum a different tune.*) Hm… hm… hm… hm… (*They continue to sing in competition.*)

Scene 7

REDILLON, PONTAGNAC, LUCIENNE.

LUCIENNE: (*Entering.*) I'm sorry to interrupt your conversation (*The two men stop singing and rise.*) but my husband is asking for you, Monsieur Pontagnac. He's desperate to show you his Corot.

PONTAGNAC: Is he…? Desperate?

LUCIENNE: It's through there, straight ahead.

PONTAGNAC: (*Going unenthusiastically.*) Through there?

LUCIENNE: Yes. Well go on.

PONTAGNAC: (*Picking up his hat and stick.*) Alright, alright. (*To Rédillon.*) Wouldn't you like to come too?

REDILLON: Me?

LUCIENNE: No. He's not keen on paintings.

PONTAGNAC: Oh! Oh, well then! (*Aside.*) I don't like leaving the two of them together. (*He goes out.*)

REDILLON walks nervously up and down.

LUCIENNE: Do sit down, my dear friend.

REDILLON: No, thank you. I came in a carriage so I need to walk.

LUCIENNE: What's the matter with you?

REDILLON: Nothing! Do I look as though something's the matter with me?

LUCIENNE: You look like a caged animal. Does he bother you?

REDILLON: Me? No, not in the least! Why do you think I'm bothered by him?

LUCIENNE: Oh, I thought…

REDILLON: Oh! Ha, ha, ha! I'm not In the least bothered by him. (*A pause.*) Who is he anyway?

LUCIENNE: I thought you weren't bothered by him.

REDILLON: Please forgive me if I'm being indiscreet.

LUCIENNE: I forgive you.

REDILLON: Thank you very much. (*A pause.*) Is he after you?

LUCIENNE: Yes.

REDILLON: (*Ironically.*) That's nice!

LUCIENNE: You think it's your exclusive privilege?

REDILLON: But it's quite different. *I* love you!

LUCIENNE: Perhaps he says the same!

REDILLON: Good God, he's only known you ten minutes!

LUCIENNE: Twenty!

REDILLON: Ten or twenty. Who's counting!

LUCIENNE: He was introduced to me twenty minutes ago. But I have known him much longer by sight. He's been following me in the street for a week.

REDILLON: No!

LUCIENNE: Yes!

REDILLON: The oaf!

LUCIENNE: Thank you!

REDILLON: And I suppose your husband thought it would be amusing to introduce you. (*LUCIENNE smiles and shrugs in confirmation.*) Charming! Honestly, these husbands! I think they do it deliberately to give themselves a thrill.

LUCIENNE: Now look here, Rédillon –

REDILLON: (*Interrupting.*) No! I say what I think! I can't bear to see another man sniffing around you. It makes me furious. But I can't tell your husband that.

LUCIENNE: Now calm down!

REDILLON: (*Crying.*) Oh, I knew something dreadful would happen today. I dreamt that all my teeth fell out. When I dream that my teeth fall out, something dreadful always happens. Last time someone stole a little dog I was fond of. And now someone is trying to steal my mistress.

LUCIENNE: Your mistress! I'm not your mistress.

REDILLON: You are the mistress of my heart. And no-one, not even you, can deny that.

LUCIENNE: As long as you don't hold me responsible!

REDILLON: Oh, swear you'll never love him!

LUCIENNE: Him? You must be out of your mind. I barely know him. Do you think I pay him the least attention?.

REDILLON: Oh, thank you. You've noticed how ugly he is, have you? Have you seen his nose? A man with a nose like that is incapable of love.

LUCIENNE: Is he?

REDILLON: Whereas I… I have the right kind of nose. I have a nose for love. A nose which loves.

LUCIENNE: How can you be sure?

REDILLON: People keep telling me.

LUCIENNE: Do they really!

REDILLON: Ah, Lucienne, you promised never to belong to anyone but me.

LUCIENNE: (*Correcting him.*) One moment, please! If I ever belong to anyone… But for that to happen, my friend, there would have to be very special circumstances.

REDILLON: (*With a sigh.*) Oh, I know. Your husband has to be unfaithful first. Ah well! (*Aside.*) What on earth is the man waiting for! Has he no passion? He's a jellyfish! (*Aloud.*) Don't you know the torture you are inflicting on me? You keep serving up the aperitif but you never let me dine!

LUCIENNE: I'm sorry. You'll just have to go and dine elsewhere!

REDILLON: Yes, I have had to!

LUCIENNE: What!

REDILLON: Well, what do you expect? I'm made of flesh and blood and I'm hungry. In fact I'm starving.

LUCIENNE: And this is the man who says he loves me!

REDILLON: But I do! It's not my fault that as well as the lover in me there is also…

LUCIENNE: What?

REDILLON: There is also a beast.

LUCIENNE: I see. Aren't you up to putting it down?

REDILLON: Pardon?

LUCIENNE: The beast, I mean.

REDILLON: I've never been able to harm dumb animals.

LUCIENNE: Ah! Well at least keep it on a lead.

REDILLON: Oh, I do. But the beast is stronger than me. Where he pulls I follow. There's nothing I can do. So I give in. I take the beast for a walk.

LUCIENNE: What's her name?

REDILLON: Who?

LUCIENNE: The dog handler.

REDILLON: Oh!… Pluplu. It's short for Pluchette.

LUCIENNE: How sweet!

REDILLON: Yes, but my heart isn't in it! Pluplu means nothing to me. I have eyes for only one woman. Only one. And that woman is you. I may sacrifice before many altars. But my burnt offering goes to you!

LUCIENNE: Really! That's very kind.

REDILLON: My body, my physical self is with Pluplu, but my thoughts are with you. I am with her, but I try to imagine it's you. I embrace her but I make believe it's you. I say 'Shut up' so I don't hear her voice. And I close my eyes and call her Lucienne.

LUCIENNE: Doesn't she mind?

REDILLON: Pluplu? Not a bit. She does the same. She closes her eyes and calls me Alphonse.

LUCIENNE: How delightful! It's a play done by understudies.

REDILLON: (*In a burst of passion.*) Oh Lucienne, Lucienne, when will you stop torturing me? When will you say to me: 'Rédillon, I'm yours! Do whatever you want with me!'? (*He kneels on the floor.*)

LUCIENNE: I beg your pardon. Would you please...

REDILLON: Oh! Lucienne! Lucienne, I love you...

LUCIENNE: Would you please get up! My husband might come in. He's found you at my feet twice already!

REDILLON: I don't care! Let him come in. Let him see me!

LUCIENNE: Certainly not! That's the last thing I want! What an idea! (*REDILLON quickly lounges nonchalantly on the floor as VATELIN enters.*)

Scene 8

LUCIENNE, REDILLON, VATELIN, PONTAGNAC.

VATELIN: (*Entering with PONTAGNAC and seeing REDILLON on the floor.*) Good heavens, you're on the floor again!

REDILLON: That's right. Er... How are you?

VATELIN: Quite well thank you. Odd habit that! (*To PONTAGNAC.*) You'll never believe it, old chap, but this is my friend Rédillon.

PONTAGNAC: We've already been introduced.

VATELIN: I've never known anyone like him. Every time he's here – and it's not as though there aren't enough chairs – I can't come in without finding him sitting on the floor...

PONTAGNAC: (*Dryly.*) Ah!

REDILLON: Perhaps I should explain. Ever since childhood, I've loved rolling about on the floor. So when I'm in company, rather than just standing about, I…

VATELIN: It really is bizarre. Do legless people run in your family?

REDILLON: (*Appreciating the joke.*) Ha! Ha! Ha! Very funny! That's very funny!

PONTAGNAC: (*Aside, looking at VATELIN.*) Oh, he was born to be a cuckold!

LUCIENNE: Well, then you've seen my husband's pictures, Monsieur Pontagnac?

VATELIN: He has indeed! He loved them! He said to me: 'The museums have nothing like this!' (*To PONTAGNAC.*) Didn't you?

PONTAGNAC: Yes, yes I did. (*Aside.*) Thank God!

VATELIN: Wait a minute! I've got some more through there. Would you like to – ?

PONTAGNAC: (*Interrupting.*) No, no! Not too many treats in one day. I'd rather keep them for another time.

VATELIN: Oh, it's a pity that poor Madame Pontagnac is so ill. I'd have been proud to show her my pictures.

PONTAGNAC: Ah! But what can one do? Her rheumatism… Yes, down in Aix.

VATELIN: Yes.

PONTAGNAC: En-Provence.

VATELIN: And in her wheelchair too! We're all mortal, all of us!

ALL: (*With a sigh.*) Ah yes!

Scene 9

LUCIENNE, PONTAGNAC, REDILLON, VATELIN, JEAN, then MME PONTAGNAC.

JEAN: (*Entering.*) Madame Pontagnac.

ALL: What?!!!

PONTAGNAC: (*Aside.*) Good Lord! My wife!

ALL: Your wife?

PONTAGNAC: What? Yes... No. I suppose it must be!

LUCIENNE: But I thought she was in Aix...

VATELIN: Nursing her rheumatism.

LUCIENNE: En-Provence.

PONTAGNAC: That's right. Well, I don't understand it... She must be cured! (*To JEAN.*) We're out, we're out, say we're out.

LUCIENNE: Certainly not, that's out of the question! Show her in.

PONTAGNAC: Yes. That's what I said. Show her in, show her in! (*Aside.*) Oh dear, oh dear, oh dear!

ALL: (*Aside.*) What on earth's the matter with him?

REDILLON: (*Aside, with pleasure.*) This fellow doesn't seem very happy.

PONTAGNAC: (*Aside.*) Oh well, here we go! (*Aloud.*) I beg you, Madame, and my dear friend... If for reasons I'll explain later, my wife starts questioning you about my whereabouts, not a word... Or rather say whatever I say... Eh?... Say whatever I say.

MME PONTAGNAC: (*Entering.*) Do forgive me ladies and gentlemen...

PONTAGNAC: You're here, my darling! What a delightful surprise. I was just leaving! So let's go! Just say good-bye to Madame and these gentlemen and then we'll be off. Good-bye. Come on. Off we go!

ALL: What!

MME PONTAGNAC: Certainly not. What an idea!

PONTAGNAC: (*Pulling her away.*) But yes! Yes!

MME PONTAGNAC: But no! No!

LUCIENNE: Now come along. Stop that!

PONTAGNAC: Right! There you are, I've stopped (*Aside.*) Oh my God, oh my God!

MME PONTAGNAC: (*Sitting.*) Do forgive me, Madame, for coming to your house like this, without even being introduced.

LUCIENNE: But, Madame, not at all. We're delighted.

VATELIN: Absolutely. Absolutely.

MME PONTAGNAC: You see, my husband's always talked so much about you.

VATELIN: Really? Ah that's nice of you... (*PONTAGNAC shakes his head.*) No it is, Pontagnac.

MME PONTAGNAC: And I said to myself: 'Things can't go on like this. Two close friends and their wives don't even know each other!'

LUCIENNE and VATELIN: Such close friends!

MME PONTAGNAC: My husband's so very fond of you that I was beginning to get jealous. Every day it's the same story: 'Where are you going?' 'To the Vatelins.' And in the evening: 'Where are you going?' 'To the Vatelins.' Always the Vatelins!

VATELIN: Really! How extraordinary! The Vatelins?

PONTAGNAC: Yes, of course! Why are you so surprised? (*Quickly to MME PONTAGNAC.*) You haven't seen his pictures have you? Come and see his pictures! They're well worth it. Come and see his pictures.

MME PONTAGNAC: No. For goodness sake, no! What's wrong with you?

PONTAGNAC: Me? Nothing! Does there seem to be something wrong?

VATELIN: What's going on?

REDILLON: (*Aside.*) This is terribly amusing! Terribly amusing!

MME PONTAGNAC: Ah ha! You seem rather jumpy. Is that because – ?

PONTAGNAC: (*Interrupting.*) Me? Jumpy? What do you mean, jumpy? I'm not moving a muscle. I just wish you'd stop telling Monsieur and Madame Vatelin that I go to their house every day! They know perfectly well that I go to their house every day.

LUCIENNE: (*Aside.*) Aha!

VATELIN: (*Aside.*) Now I understand!

PONTAGNAC: (*To VATELIN.*) I mean, Vatelin, you know perfectly well that I come to your house every day, don't you?

VATELIN: Yes, yes, yes, yes, yes!

PONTAGNAC: There you see!

REDILLON: Even I've met him here.

PONTAGNAC: (*Astonished, aside.*) Eh!… (*Aloud.*) Thank you, Monsieur.

REDILLON: Not at all.

PONTAGNAC: There! Are you convinced?

MME PONTAGNAC: (*Doubtfully.*) Yes.

PONTAGNAC: (*Angrily.*) Oh, for heaven's sake!

VATELIN: (*Aside.*) Poor Pontagnac, I feel really sorry for him! (*Quietly to PONTAGNAC.*) Hang on, I'm going to get you out of this!

PONTAGNAC: Please do!

VATELIN: Of course, Madame, my friend Pontagnac has often spoken about you during his frequent visits here.

MME PONTAGNAC: Really?

PONTAGNAC: (*Quietly.*) That's it! Keep it up!

VATELIN: I'd have asked him to introduce us long ago if you hadn't been down in Aix.

MME PONTAGNAC: Aix?

VATELIN: En-Provence

PONTAGNAC: (*Aside.*) This is it! (*Aloud.*) No! No! No! Aix? What do you mean, Aix? Why did you say Aix?

VATELIN: (*Bewildered.*) What do you mean X. Did I say X?

PONTAGNAC: Yes. Why? Why say anything about Aix?

VATELIN: (*Trying to recover.*) YX…? Why did I say X? What I meant was that if I'd known you were… you were…

PONTAGNAC: Nowhere!

VATELIN: (*Completely lost.*) Exactly. That you were nowhere!

PONTAGNAC: So that's alright. That's right (*Quickly.*) Now please shut up!

VATELIN: With pleasure. I don't know what I'm saying any more!

REDILLON: (*Aside.*) They're in a bit of a mess, aren't they?

MME PONTAGNAC: (*Aside.*) I'm beginning to think I was right to be suspicious. (*Aloud.*) Monsieur Vatelin, don't apologise. I didn't expect you to call. My husband told me about your condition.

PONTAGNAC: (*Aside.*) Here we go again!

VATELIN: My condition?

MME PONTAGNAC: Yes. You being crippled with rheumatism.

VATELIN: I think that's you.

MME PONTAGNAC: Me? Oh no, it's you! That's why you have to be pushed around in a bath-chair.

VATELIN: Excuse me, but that's you.

PONTAGNAC: No it's you! You don't need to put on a show in front of my wife.

VATELIN: Oh, it's me! Fine! fine! Yes. Me too.

PONTAGNAC: No. Not you too! Look, come and show me your pictures! I haven't seen all of them.

VATELIN: I'd be delighted.

MME PONTAGNAC: Edmond, please stay where you are!

PONTAGNAC: I'm coming back! I'm coming back!

VATELIN: We're coming back! We're coming back!

They exit.

Scene 10

LUCIENNE, REDILLON, MME PONTAGNAC.

MME PONTAGNAC: Listen, Madame, be honest. Are they making a fool of me?

LUCIENNE: Well, Madame, yes. Men always stick together. So women ought to show a little solidarity too. Yes, they are making a fool of you.

MME PONTAGNAC: Oh, I knew it!

LUCIENNE: Your husband is not a close friend of mine. He has never set foot in this house before. And he didn't come here today to visit a friend, but to pursue a woman he'd chased right into her own drawing room.

MME PONTAGNAC: A woman!

LUCIENNE: Yes. Me!

MME PONTAGNAC: No!

LUCIENNE: And then having followed me in the street with a persistence that I can only call...

REDILLON: Utterly boorish!

MME PONTAGNAC: Oh, how dreadful!

LUCIENNE: He found to his great disappointment that I was the wife of one of his friends. That was unlucky...! Never mind...! Your husband lied to you. His fictional visits here were alibis for his other escapades!

MME PONTAGNAC: Oh, the wretch!

REDILLON: That's the word!

LUCIENNE: Forgive me, Madame, for speaking so frankly, but I have behaved to you as I would want anyone to behave to me. If ever my husband were unfaithful…

REDILLON: (*Gloomily.*) Oh yes! But him! Nothing doing there.

LUCIENNE: Fortunately, you mean!

MME PONTAGNAC: Now I know what I wanted to know! Now we'll have it out, Monsieur Pontagnac! I'll lie low. I'll spy on you. I'll have you followed. I'll catch you 'In flagrante delicto'. And then…!

LUCIENNE: And then?

MME PONTAGNAC: (*Laughing.*) Ah! Ah! Ah! I'll say no more.

LUCIENNE: You'll give him a taste of his own medicine?

MME PONTAGNAC: I will!

REDILLON: Bravo!

LUCIENNE: (*Stirred by MME PONTAGNAC.*) Oh, Madame, you're just like me. If ever my husband…

REDILLON: Yes, yes!

MME PONTAGNAC: After all! I'm young. I'm pretty!

LUCIENNE: So am I!

MME PONTAGNAC: It may not be modest to say so.

REDILLON: Never mind! When you're angry, you don't need to be modest!

MME PONTAGNAC: In any case, I can think of several men who would be delighted...

REDILLON: Well I never!

LUCIENNE: So can I! Can't I, Rédillon?

REDILLON: Oh, you two...! Really!

MME PONTAGNAC: And don't think I would be too choosy! I wouldn't. No, it wouldn't matter who. The first idiot who comes along.

REDILLON: Is that so?

MME PONTAGNAC: (*To REDILLON.*) You for instance. If you'd like.

REDILLON: Me? Ah Madame...

LUCIENNE: That's right. And me too!

REDILLON: Ah, Lucienne!

MME PONTAGNAC: Can I have your name and address?

REDILLON: Rédillon, 17 Rue Caumartin.

MME PONTAGNAC: Rédillon, 17 Rue Caumartin. Good! Well, Monsieur Rédillon, if ever I catch my husband, I will rush straight round to you and say: 'Monsieur Rédillon, take me. I am yours!' (*She falls into his arms.*)

LUCIENNE: (*Also falling into his arms.*) And me too, Rédillon! Yours! Yours!

REDILLON: (*The two women in his arms.*) Oh, my dear ladies! (*Aside.*) Why does my luck always come with strings attached?

Sound of voices.

MME PONTAGNAC: Our husbands! Not a word!

Scene 11

MME PONTAGNAC, LUCIENNE, REDILLON, VATELIN, PONTAGNAC.

VATELIN and PONTAGNAC enter.

MME PONTAGNAC: Well, have you been looking at the pictures? Did you like what you saw?

PONTAGNAC: Immensely. Immensely! There are some canvasses in particular… Ah, what canvasses! By close relatives of the great masters.

VATELIN: Yes, there are indeed.

PONTAGNAC: There's one by Corot's son. And another by Renoir's cousin. Really, it's scarcely worth bothering with the masters themselves.

VATELIN: That's just what I say. They're just as well done. And often better finished.

REDILLON: And much less expensive.

MME PONTAGNAC: Yes! In the meantime, Madame Vatelin and I have been getting to know each other. We've been talking about you a great deal.

PONTAGNAC: (*Anxious.*) Really.

MME PONTAGNAC: (*Indicating REDILLON.*) And this gentleman has told me that he has met you often and thinks very highly of you.

PONTAGNAC: No. He said that? (*To REDILLON.*) Thank you. (*Aside.*) And I thought he was a… (*Aloud.*) My dear Monsieur Steadillon.

REDILLON: Rédi… Rédi…

PONTAGNAC: Oh, I'm so sorry! Rédillon! Ready, Steady, Go… it's all the same! Monsieur Rédillon, Madame Pontagnac.

MME PONTAGNAC: We've had time to introduce ourselves!

PONTAGNAC: Really. Excellent! So! (*To REDILLON.*) My dear fellow, my wife is at home every Friday if you would do us the honour...

REDILLON: I'd be delighted! (*Aside.*) That's rich! When he was the lover, I got the cold shoulder. But once his wife arrives, the husband reappears and starts doling out invitations. They're all the same!

Scene 12

MME PONTAGNAC, REDILLON, PONTAGNAC, LUCIENNE, VATELIN, JEAN.

JEAN: (*Entering.*) There's a lady asking for you, Monsieur.

VATELIN: For me? Who is it?

JEAN: I don't know. I've never seen her before.

LUCIENNE: A lady? Is she pretty? What does she want?

VATELIN: Oh, who knows, my dear? (*To JEAN.*) Did you say I was in?

JEAN: Yes. The lady is waiting in the small drawing room.

VATELIN: Good. Then let her wait. I'll be with her in a moment.

JEAN exits.

MME PONTAGNAC: Monsieur Vatelin, I don't want to take up your time. Especially when you have a lady to attend to.

VATELIN: It's only a client! There's no hurry! It's not the man she's come to see, but the lawyer.

LUCIENNE: So I should hope!

MME PONTAGNAC: Good-bye, dear Madame! It's been delightful, Monsieur.

PONTAGNAC: Rédillon!

REDILLON: 17, Rue Caumartin, to be precise.

MME PONTAGNAC: That's right!

REDILLON: I'll come with you. I have some shopping I must do. (*To LUCIENNE, in a low voice.*) Farewell, Lucienne, my darling. (*To VATELIN.*) Good-bye, old chap.

PONTAGNAC: Come on, let's go. *(He shakes hands with VATELIN and then with LUCIENNE.)* Madame! (*Quickly and quietly.*) I'll see my wife home and then come back and explain.

MME PONTAGNAC: Are you coming?

PONTAGNAC: Of course, of course.

MME PONTAGNAC: (*Aside.*) From now on, he'd better watch his step!

They exit.

Scene 13

LUCIENNE, VATELIN, then JEAN, then MITZI.

VATELIN: Would you give me a moment, darling, while I get rid of this woman? (*He rings the bell.*)

LUCIENNE: Of course. I'll see you very soon, darling. (*She exits.*)

JEAN: You rang, Sir?

VATELIN: Yes. Show the lady in. (*JEAN ushers in MITZI, then exits. VATELIN sits at the table, shuffling his papers, and pretending to be busy.*) If you'd just take a seat, Madame.

MITZI: (*Coming up behind him and planting two big kisses on his head. She has a pronounced Swiss accent.*) Ach! Mein Liebling! Hallo!

VATELIN: (*Rising, recognising MITZI.*) What! Madame Soldignac! Mitzi! It's you!

MITZI: In the flesh.

VATELIN: But what are you doing here? You're out of your mind!

MITZI: Warum?

VATELIN: Well, what about Zürich?

MITZI: I have left it behind!

VATELIN: And your husband?

MITZI: Him I brought with me. He's come to Paris on business!

VATELIN: Has he really? And what have you come for?

MITZI: What? What have I come for? Wie kannst du mir fragen? Undankbarer! Ich habe alles für dich aufgegeben.

VATELIN: Yes! Yes! Absolutely! (*He goes and listens at his wife's door.*)

MITZI: Ich hab Zürich verlassen... Ich fahre über die Alpen und wenn ich endlich ankomme fragt er mich warum ich gekommen bin!

VATELIN: Yes alright. But that's not what I asked! You're speaking German and I don't understand a word! Why are you here? What do you want?

MITZI: What do I want? (*Aside.*) He asks me what I want! (*Aloud.*) I want you!

VATELIN: Me?

MITZI: Ach, ja! Because I love you still! Ach, mein Gott, I have left Zürich to find you. I have crossed the Alps which made me ill as I suffer from vertigo. I was sick. I have thrown up... I have thrown up... How shall I put it?

VATELIN: I should leave it just where it is.

MITZI: I nearly died but I didn't care! I said I would see him. And I am here for seven days. (*She sits down.*)

VATELIN: Seven days! A week! You're here for a whole week?

MITZI: Yes, a week. Just for you. Why haven't you answered my letters. I was already saying, 'Oh my Crépine, he loves me no more.' Oh ja, ja, du liebst mich doch! Crépine, please say to me that you love me.

VATELIN: Of course I do, of course I do!

MITZI: When I arrived this morning, I wrote to you. And then I didn't send the letter. Perhaps he won't reply... So I threw it in the wastepaper basket. And I came straight here. Oh! Crépine, Crépine, how happy I am! You'll come and see me this evening... nicht wahr?

VATELIN: What! Well, I'll have to um, have to...

MITZI: Ach! Don't say nein! This morning I found a little ground floor apartment, furnished as I told you in this letter that I threw in the wastepaper basket – forty-eight, Rue Rockerpiner.

VATELIN: Roquépine, Rue Roquépine. You're staying in Rue Roquépine?

MITZI: Ach! No! I'm with my husband in the Hotel Schwartzwaldgemeinschaftsgebäudegesellschaft. But

the apartment's for the two of us. I have rented it
and this evening you will come. Nicht wahr?

VATELIN: Me! Ah no! Nein! No!

MITZI: Nein! Why nein?

VATELIN: Well... because! Because it's impossible! I'm
not free! I have a wife. I do. I'm married. I am!

MITZI: You're not! You're not married!

VATELIN: I certainly am!

MITZI: Ach, in Zürich, you said you were a bachelor.
Unattached.

VATELIN: Well, I was unattached in Zürich –

MITZI: Genau. That's what you said.

VATELIN: Because I'd left my wife in Paris. It's a
figure of speech.

MITZI: Ach, mein Gott! I see. Crépine, are we finished?

VATELIN: Look, Mitzi. Please be reasonable.

MITZI: And you will never make love to me again?
Never!

VATELIN: Oh, yes! The very next time I'm in Zürich!
How about that?

MITZI: (*Bursting into tears.*) Ach! Crépine doesn't love me
any more! Crépine doesn't love me any more!

VATELIN: (*Rushes to LUCIENNE's door.*) Will you please
be quiet! My wife will hear you.

MITZI: Es ist mir egal. I don't care.

VATELIN: Yes, but I do! Please be sensible! I'm very
touched, of course, but our little romance born in
Zürich was never meant to have a future. How could

it? We met in a cablecar. You were giddy. I was giddy.
You were sick. I was sick. We were both ill. It was fate.
What can happen did happen. Let's content ourselves
with the memory of that special time, not try and start
it all over again. Besides I can't make love to you here
in Paris. There it was different: I had an excuse. There
are things you can do on one side of the Alps which
you can't do on the other. So follow my example. Deny
yourself as I do daily. And forget me. There must be
other attractive men in Zürich.

MITZI: Nein, nein. I am a faithful woman. One husband.
One lover. Full stop!

VATELIN: Splendid! A woman of principle.

MITZI: (*Suddenly.*) Oh, Crépine! Crépine! Don't you
desire me any more?

VATELIN: Now look! You must understand…

MITZI: Ja, ja. Natürlich! (*She rises sadly.*) Good-bye, Crépine!

VATELIN: (*Goes to open the door.*) Good-bye, dear lady.
Allow me to show you out. (*He shows her out and shuts
the door after her.*) Good-bye. Good-bye.

MITZI: (*Re-enters in hysterics.*) Ach, das hab ich schon
gewust. I knew it all along! When I received no
reply to my letters, I wrote a note to my husband.
Now I shall send it to him.

VATELIN: What?

MITZI: Good-bye, my darlingest man. Forget me! Your
guilty wife has nothing left but death.

VATELIN: That's tragic!

MITZI: I have been the mistress of Monsieur Vatelin,
28, Rue Thremol…

VATELIN: Vatelin? That's my name. And my address!

MITZI: He has… He has rejected me and I am killing myself.

VATELIN: No! Never, never, never! You kill yourself? And with my name and address?

MITZI: Selbstverständlich.

VATELIN: Mitzi, my little Mitzi…

MITZI: Little Mitzi is no more.

VATELIN: Don't be ridiculous! You wouldn't do it, Mitzi, would you?

MITZI: Not if you come this evening, forty-eight, Rue Rockerpiner.

VATELIN: But I've just told you I can't! What excuse can I give my wife?

MITZI: Nein? Very well. I will kill myself!

The front door bell rings

VATELIN: Oh my God! Alright then. I'll be there.

MITZI: Ja? And you'll make love to me again?

VATELIN: And I will make love to you again. There! (*Aside, angrily.*) Ouh!

MITZI: Oh I am so happy! Crépine, I love you!

VATELIN: (*Aside.*) Ouh! Damn the woman! Why couldn't she have stayed in Zürich!

Scene 14

VATELIN, MITZI, JEAN, then LUCIENNE, then SOLDIGNAC, then PONTAGNAC.

JEAN: (*Entering.*) A gentleman is asking if Monsieur is at home?

VATELIN: Who is it?

JEAN: Herr Soldignac.

MITZI: (*Aside.*) Mein mann!

VATELIN: What!

MITZI: Mein husband!

VATELIN: Husband! (*To JEAN.*) I'll be with him right away. (*JEAN exits.*) What on earth does he want?

MITZI: I've no idea! Perhaps as he's in town, he's come to see you.

VATELIN: Yes. Well he musn't see you! Come out through here! (*He leads her out.*)

MITZI: Alright! Until this evening then!

VATELIN: Yes, yes, I know.

MITZI: Forty-eight, Rue Rockerpiner!

VATELIN: Roquépine, Rue Roquépine! (*Gives up.*) Just go! Go!

MITZI: I'm going! I'm going! Bye-bye. (*Exits.*)

LUCIENNE: (*Entering.*) Has the lady gone?

VATELIN: Yes. Oh, yes!

LUCIENNE: Then who was at the door?

VATELIN: A man I met in Zürich.

JEAN: (*Entering.*) Herr Soldignac!

SOLDIGNAC: (*Entering, with a Swiss accent.*) Eh! My dear friend! Hello! How are you?

VATELIN: (*Shaking hands.*) I'm well. What a pleasant surprise!

SOLDIGNAC greets LUCIENNE.

Darling, Herr Soldignac!

LUCIENNE: Monsieur!

SOLDIGNAC: Madame Vatelin, I presume. Very good. Very good. My dear friend, I've only looked in for a moment! I am very busy, you know. An evening I could manage, I could make the time. But during the day... Geschäft... Business! Well, geschäft ist geschäft as we say in Switzerland. So, I just rushed in to say hello and have a word about my wife.

VATELIN: I hope she's well, Madame Soldignac...?

SOLDIGNAC: Oh, very well, thank you! Indeed it's because of her that I'm here. I've discovered something, my dear friend – you'll be very surprised. I've discovered I'm a cuckoo.

VATELIN: How very Swiss!

SOLDIGNAC: No, a cuckoo. A cuckoo. Madame Soldignac is deceiving me.

VATELIN: What?

LUCIENNE: If you'll forgive me, I think I'm in the way. I'll leave you.

SOLDIGNAC: Oh no, I don't mind a bit. I'm very philosophical about it. But I must hurry because I have business to attend to. This morning I stumbled quite by chance on this letter at the bottom of my wife's wastepaper basket.

VATELIN: (*Aside.*) Good God! The letter she wrote to me. I hope she hasn't mentioned my name.

SOLDIGNAC: (*Reading.*) 'Liebling...'

VATELIN: (*Aside, relieved.*) Liebling! No… That's not me!

SOLDIGNAC: 'I am in Paris. So we can love once more each other again.' You understand?

VATELIN: Yes, I think so.

SOLDIGNAC: 'Tonight my husband' – that's me – 'will be working late. I am alone, come to me at 48, Rue Rockerpiner, on the ground floor. I'll be waiting for you! Mitzi.' What do you make of that…?

VATELIN: Well you know, you shouldn't leap to… I mean not immediately. There might be nothing to it at all.

SOLDIGNAC: I'm no fool! In between meetings, I rushed out to see the Police Superintendent. And this evening, though I don't know this Liebling, I shall nab the two of them together – her and Liebling – at forty-eight, Rue Rockerpiner.

VATELIN: (*Aside.*) Phew! Thanks for the warning.

SOLDIGNAC: (*To LUCIENNE.*) Am I not in the right, Madame?

LUCIENNE: Well, I must say, Monsieur…

SOLDIGNAC: Yes, and then I'll divorce her.

VATELIN: What! You want a divorce?

SOLDIGNAC: Absolutely! I'd be delighted. My wife bores me. She's so moody and it distracts me from my business. I've come to see you as my lawyer to ask you to prepare the divorce papers immediately.

VATELIN: Me!

SOLDIGNAC: Yes. Because I'm in a very great hurry.

VATELIN: But I'm not authorised to… What are you talking about? You must do it in Zürich!

SOLDIGNAC: Why Zürich? I'm not from Zürich.

VATELIN: Aren't you?

SOLDIGNAC: Nein, I'm from Marseilles!

VATELIM and LUCIENNE: Marseilles?

SOLDIGNAC: Yes, Narcisse Soldignac from Marseilles. I was brought up in Switzerland, and then stayed on there... for business. I got married there too, but in the French Consulate. So you can handle the divorce.

VATELIN: Ah! I see, because you're...

SOLDIGNAC: Yes, of course. Because I'm French. Ich bin Französich!

VATELIN: Ah well, of course, I must. (*Aside.*) But I'd be citing myself. This is ridiculous!

SOLDIGNAC: That's all settled then? I'm sorry but I'm in a hurry.

VATELIN: (*Aside.*) Well, what have I got to lose? (*Aloud.*) Right, it's agreed, subject to one essential condition: that you catch your wife and her lover red-handed!

SOLDIGNAC: Of course. I'll catch them tonight, at forty-eight Rue Rockerpiner.

VATELIN: (*Aside.*) Oh, will you? I'm not that stupid!

SOLDIGNAC: And as for this Liebling, I shall give myself the pleasure, once I get my hands on him, of giving him a little boxing lesson.

VATELIN: Ah! Then you're good at the old... (*He boxes.*)

SOLDIGNAC: Me? Very good. So is my wife. I taught her. When I was younger, I fought the reigning Swiss champion. I thrashed the living daylights out of him. I gave him a punch that sent him clear over the Alps.

LUCIENNE: Oh, you exaggerate! It must be the Latin in you.

SOLDIGNAC: Does that surprise you? You may think I'm Swiss and impassive, but underneath I have a Mediterranean temperament. (*Lyrically.*) Even in the mists of Zürich, I can still find a ray of southern sunshine.

LUCIENNE: Oh, you're a poet.

SOLDIGNAC: No, I'm too busy. I don't have the time. Geschäft ist geschäft, as we say in Zürich. Good-bye! And as for this gentleman, this evening: (*Putting up his fists.*) 'Di gou li gue vengue', as we say in Marseilles. Vengeance will be mine. Auf wiedersehen!

He goes to the door and bumps into PONTAGNAC who is just entering.

PONTAGNAC: Oh, I beg your pardon!

SOLDIGNAC: Good-bye, Monsieur! I'm in a very great hurry.

VATELIN: Pontagnac! Well-timed. You're just the man. (*To LUCIENNE.*) Would you show Monsieur Soldignac out, my dear? I want a word with Pontagnac.

LUCIENNE: (*Going out, following SOLDIGNAC.*) With pleasure.

Scene 15

PONTAGNAC, VATELIN.

PONTAGNAC: Who was that ugly customer?

VATELIN: No one. He's Swiss. From Marseilles. It's lucky you came back. I have a favour to ask you.

PONTAGNAC: Me?

VATELIN: Yes. Man to man. This evening I have a rendez-vous with a lady.

PONTAGNAC: You do! Ah! I'm thunderstruck!

VATELIN: Yes. Well, that's how it is.

PONTAGNAC: You're deceiving your wife?

VATELIN: Circumstances sometimes oblige a husband to, um…

PONTAGNAC: (*Aside, delighted.*) He's deceiving his wife and he's confiding in me.

VATELIN: And that's it. We had a rendez-vous at a special place, but now there are private – and compelling – reasons that prevent us going there. You know about these things. I suppose you couldn't recommend a hotel where I could…?

PONTAGNAC: Why yes! Yes, of course! There's the Continental, and the Grand Hotel. And then there's the Ultimus. That's where I always go. It's very convenient, and has lots of exits. Just send a telegram and they'll keep you a room for this evening.

VATELIN: Thank you, my dear friend, thank you! I'll go and send a telegram immediately. And one to the lady so that she can ask for the room that's in my name.

PONTAGNAC: That's right. That's right! But will your wife allow you out this evening?

VATELIN: Oh that's not difficult. My work often takes me out of Paris. I'll just say that I've been called out of town about a will, or a sale of the deceased's property!

PONTAGNAC: Splendid! Splendid!

VATELIN: Excuse me, I must go and send those telegrams. (*He exits.*)

Scene 16

PONTAGNAC, then LUCIENNE.

PONTAGNAC: (*Aside.*) He's being unfaithful to his wife! Oh what luck!

LUCIENNE: (*Re-entering, aside.*) They're very odd people, the Swiss.

PONTAGNAC: Lucienne! Quick, come here!

LUCIENNE: What on earth's the matter?

PONTAGNAC: Well, I... (*Aside.*) Oh! No, no, no. I can't!

LUCIENNE: What is it?

PONTAGNAC: (*Aside.*) Oh well... It's just too bad! I don't owe Vatelin anything. He's not a close friend and besides, love conquers all!

LUCIENNE: Well?

PONTAGNAC: You'll be true to your word, won't you? You said to me, 'I will never be the first to be unfaithful. But if my husband strays, I will not hesitate to pay him back'.

LUCIENNE: Yes, I did say that!

PONTAGNAC: You swear you'll do it. You'll deceive him immediately if you ever have the proof!

LUCIENNE: Indeed I will! Immediately.

PONTAGNAC: Well I have the proof! Tonight at the Hotel Ultimus, your husband and another woman will meet and –

LUCIENNE: (*Interrupting.*) No, no, you're lying!

PONTAGNAC: Lying? In a moment he will come in and tell you that he's received a telegram which

requires him to go out of town. It's either about a will or a sale of the deceased's property.

LUCIENNE: Oh, I don't believe it! How could he do such a thing. Crépin?

PONTAGNAC: Yes. Crépin!

LUCIENNE: You'll have to prove it. You'll have to prove it!

PONTAGNAC: Alright! I'll wait until he has gone out tonight and then I'll collect you and take you to the scene of the crime: the Hotel Ultimus. Will that satisfy you?

LUCIENNE: Oh yes, that will satisfy me. That will satisfy me! That's what I require!

PONTAGNAC: It's him! Keep calm.

Scene 17

LUCIENNE, PONTAGNAC, VATELIN.

VATELIN: (*Entering.*) Oh darling, there you are. I'm afraid I've had a spot of bad luck.

LUCIENNE: Oh, really? What is it?

PONTAGNAC: (*Aside.*) Keep it up! Keep it up!

VATELIN: Would you believe it, I've just had a telegram which means I must leave Paris tonight on the eight o'clock train.

LUCIENNE: (*Aside.*) Then it's true!

VATELIN: I'm due in Amiens for the reading of a will.

LUCIENNE: (*Aside.*) The bastard! (*Aloud.*) Couldn't one of your staff go instead?

VATELIN: Oh no, it's impossible! They want me there in person.

LUCIENNE: I see. Then of course you must go, my dear. My God, business is certainly business, as your Swiss friend keeps saying!

VATELIN: Yes, it certainly is. But I'm very put out about this.

LUCIENNE: (*Aside.*) The hypocrite!

VATELIN: Please excuse me, I must go and send more telegrams!

He exits.

PONTAGNAC: Well? Are you satisfied?

LUCIENNE: Oh, the brute! I believed he was one of those rare, faithful husbands. And instead he is just like all the rest! (*Decisively.*) Very well, Monsieur Pontagnac. I'll be waiting for you tonight. If you can give me proof... Ah...! I swear to you that within the hour, I will be avenged.

PONTAGNAC: Oh, thank you very much. (*Aside.*) I have to admit I'm being a bit of a shit... But bah! I have an excuse! I want his wife! I want her! (*Aloud.*) Until tonight. (*He goes to one door.*)

LUCIENNE: (*She goes to the other door.*) Until tonight!

They exit.

End of Act One.

ACT TWO

Scene 1

Room No 39, the Hotel Ultimus. A bed in an alcove. Upstage, the main door to the corridor. Downstage left, a connecting door to Room 38. Stage right, a door leading to the bathroom.

ARMANDINE, then VICTOR.

As the curtain rises, ARMANDINE is closing a travelling bag. There is a knock at the door.

ARMANDINE: Come in! (*Seeing VICTOR.*) Ah, there you are, young man. Now then, have you done as I asked?

VICTOR: Yes, Madame. The Manager's coming up immediately.

ARMANDINE: You spoke to him about changing the room?

VICTOR: Oh yes, Madame. He knew anyway. The chambermaid had told him.

ARMANDINE: Good. Thank you, young man. (*Aside.*) He's rather sweet. (*Aloud.*) Come over here.

VICTOR: Madame!

ARMANDINE: How old are you?

VICTOR: Seventeen.

ARMANDINE: Seventeen! You know, you're rather sweet.

VICTOR: (*Looking at the ground.*) Oh, Madame!

ARMANDINE: Does that make you blush? I think you rather like it.

VICTOR: Oh yes! Coming from you! (*He closes his eyes.*)

ARMANDINE: (*Caressing his face.*) Well, I can't deny it. You're very, very sweet!

As ARMANDINE's hand hovers over him, VICTOR, in a moment of passion, kisses her in a frenzy.

ARMANDINE: My goodness! What's all this?

VICTOR: Oh! Forgive me, Madame!

ARMANDINE: Now don't get upset, young man.

VICTOR: Oh Madame, I hope I haven't hurt Madame?

ARMANDINE: Not much! Some liberties don't hurt a woman at all.

VICTOR: Madame won't tell the manager. He'd have me thrown out!

ARMANDINE: (*Laughing.*) I'm not that mean.

VICTOR: When I felt Madame's hand so warm and soft on my cheek, I trembled. Everything went round and round! Remember, Madame, that I'm seventeen and that ever since I've been seventeen… I don't know… look Madame, I keep getting these boils! Look, Madame, here! And here's one starting on my neck. (*Showing the boil.*) I showed it to a doctor who's staying at the hotel and he said to me, 'My boy, that's puberty'.

ARMANDINE: Puberty? What's puberty?

VICTOR: I don't know! Apparently I'm the right age for love. Oh, I knew the sap was rising in me.

ARMANDINE: Yes, yes, yes!

VICTOR: So when Madame started to… I do hope you're not cross with me?

ARMANDINE: No. Not at all! And to prove it, here's three francs.

VICTOR: Three francs!

ARMANDINE: It's for you.

VICTOR: Oh no! No! No! (*He slams the coins down on the table.*)

ARMANDINE: What?

VICTOR: Oh no! Not from Madame! Not from you!

ARMANDINE: Now come along!

VICTOR: I would give double that if I you'd let me…

ARMANDINE: What?

VICTOR: (*Nearly speechless.*) Nothing, Madame. (*A knock at the door.*) Here's the manager, Madame. (*He runs to the door.*)

ARMANDINE: Poor boy!

VICTOR opens the door for the MANAGER, and goes out.

Scene 2

ARMANDINE, MANAGER.

MANAGER: Madame sent for me?

ARMANDINE: Indeed I did. About the room. What's happening? (*She closes her trunk.*)

MANAGER: It's all taken care of, Madame. We'll give you another room at the front.

ARMANDINE: If it's not too much trouble.

MANAGER: It's no trouble at all, Madame. And even if Madame wanted to keep this room, I couldn't let you have it now. It's been taken by somebody else.

ARMANDINE: Oh, really?

MANAGER: A Monsieur Vatelin. He telegraphed for a room so I gave him this one.

ARMANDINE: Vatelin. I've never heard of him.

MANAGER: I shall give Madame No. 17. It looks over the street.

ARMANDINE: I must have a large, comfortable room... big enough to entertain a friend or two even if they wish to stay the night.

MANAGER: Ah! It's not just for Madame! Good, good, good. Yes, yes, yes. Now I understand. Madame would like a room where if necessary, she can... Oh in that case, I'm going to give you No. 23. That will do much better. It has twin beds.

ARMANDINE: What do you expect me to do with twin beds? Are you trying to make a fool of me?

MANAGER: Well, Madame, I...

ARMANDINE: Do you think I'm inviting an audience?

MANAGER: Oh, Madame!

ARMANDINE: No, no, I prefer No. 17.

MANAGER: Very good, Madame!

ARMANDINE: Send someone up for my trunk.

MANAGER: Yes, Madame! (*He goes outside, but before shutting the door, speaks to someone in the corridor.*) Oh Monsieur? It's here, Monsieur. (*He comes back into the room.*) There's a gentleman to see you.

ARMANDINE: A gentleman? What gentleman?

MANAGER: You'll find out. (*To the unseen man in the corridor.*) If Monsieur would care to come in! (*He shows in REDILLON and exits.*)

Scene 3

ARMANDINE, REDILLON.

REDILLON: (*From the door.*) Hello!

ARMANDINE: It's you!

REDILLON: Yes, it's me.

ARMANDINE: All well! I mean... you know... here we are then. Yes...

REDILLON: Yes... well... I'm here!

ARMANDINE: And how have you been since I saw you last?

REDILLON: Very well. May I?

ARMANDINE: What?

REDILLON purses his lips.

ARMANDINE: Oh yes, yes! (*They kiss each other passionately on the lips.*)

REDILLON: Sublime!

ARMANDINE: Then you love me?

REDILLON: I adore you!

ARMANDINE: You're quick off the mark! What's your name again?

REDILLON: Ernest!

ARMANDINE: Ernest what? You must have another name?

REDILLON: Oh yes, yes, yes! Rédillon!

ARMANDINE: What a stupid name!

REDILLON: Stupid? It's served my family well for centuries.

ARMANDINE: Well, the name doesn't make the man, does it? Look at me. You're really rather good looking. Do you know what I think?

REDILLON: No!

ARMANDINE: You look like my lover!

REDILLON: Really! Who the devil is your lover?

ARMANDINE: Who is he? He's a very classy type. He's the Baron Schmitz-Mayer.

REDILLON: Jewish, is he?

ARMANDINE: Yes, but he's never been baptised. He's the Schmitz-Mayer who rides in steeple-chases. His sister married a duke.

REDILLON: I dare say. Look, I didn't come here to study your lover's family tree.

ARMANDINE: He's doing a month's military service at the moment. That's why he's not here.

REDILLON: All well! It's an ill-wind. Confined to barracks, is he? My little Armandine! (*REDILLON purses his lips again.*)

ARMANDINE: What?

ARMANDINE: Ah! (*Realising he wants a kiss.*) I noticed you making eyes at me last night at the theatre!

REDILLON: I certainly was.

ARMANDINE: Was that Pluplu in the box with you?

REDILLON: Pluplu? Do you know her?

ARMANDINE: Of course I know her. Just as she knows me. By sight! She's a very elegant girl.

Actually that's what made me fancy you. Otherwise
I wouldn't have allowed you to catch my eye.
Because usually, of course, when I don't know
people, I don't…

REDILLON: What?

ARMANDINE: Catch their eye. But if the gentleman is
escorting a really elegant lady… it's exciting. That's
why I had the usherette give you my card in the
interval.

REDILLON: Yes, I see. so I owe all this to Pluplu?

ARMANDINE: Yes. But don't go telling her will you.

REDILLON: Don't be silly!

ARMANDINE: Because I wouldn't want to play her a
dirty trick.

REDILLON: (*Staring at her.*) I wouldn't worry. You're
wonderfully put together, you know. Is it yours, all
that?

ARMANDINE: Whose would you like it to be?

REDILLON: Mine. Only mine!

ARMANDINE: Oh, you glutton! But you'll let me have
it back?

REDILLON: Of course.

ARMANDINE: Good. Because I know someone who
wouldn't be very pleased to lose it. And it's
Schmitz-Mayer!

REDILLON: Damn it all! Do we have to keep talking
about Schmitz-Mayer!

ARMANDINE: But he loves me so much. He's always
saying, 'I love you because you're stupid!'. I'm not
stupid, am I?

REDILLON: No. You're not stupid. Oh, my little Armandine… (*They embrace.*)

ARMANDINE: Oh, my little… What was your name again?

REDILLON: Ernest!

ARMANDINE: My little Ernest!

REDILLON: (*He sits her on to his knees.*) Sit on my lap!

ARMANDINE: Oh! Already?

REDILLON: Yes, already! Oh Lucienne! My Lucienne!

ARMANDINE: What do you mean, 'Lucienne'? My name isn't Lucienne! It's Armandine!

REDILLON: (*Still in ecstasy.*) No, Lucienne! Let me call you Lucienne! It won't matter to you and I prefer it. Ah Lucienne! My Lucienne!

ARMANDINE: You are funny! Listen, that reminds me of the time…

REDILLON: (*Still in ecstasy.*) No, that reminds you of nothing! Shut up, don't speak, and kiss me! Lucienne! My Lucienne! Is it you? Is it really you?

ARMANDINE: No, it isn't!

REDILLON: Oh, do shut up! I'm not asking you for an answer! Just tell me that it's you…

A knock at the door.

ARMANDINE: Who's there?

REDILLON: (*Drowning the offstage voice.*) Oh Lucienne! My Lucienne!

ARMANDINE: (*To REDILLON.*) Will you stop it, please. I can't hear a thing. (*To the door.*) Who's there?

VICTOR: (*Offstage.*) Victor, Madame. The page.

ARMANDINE: Oh it's you! Come in!

Scene 4

REDILLON, ARMANDINE, VICTOR, then CLARA.

VICTOR: (*Entering.*) Madame, may I…? (*He stares, scandalised at the sight of ARMANDINE and REDILLON.*) Oh! (*Despondently.*) Oh!

ARMANDINE: What's the matter, young man?

VICTOR: I need to know if we can move your trunk, Madame.

ARMANDINE: Yes, of course!

REDILLON: (*To VICTOR.*) What trunk?

VICTOR: (*Sharply to REDILLON.*) That trunk there, of course! And it's not the Queen of England's!

REDILLON: (*Rising, furious.*) Hey! Don't you talk to me like that! I'll show you if it's the Queen of England's! Have you ever seen such behaviour!

ARMANDINE: Oh, don't bully him. He's really very sweet!

REDILLON: I dare say he is, but I'll teach him to be polite.

ARMANDINE: Give him five francs instead.

REDILLON: What? After the way…

ARMANDINE: You're surely not refusing to give him five francs?

REDILLON: It's not the five francs! But damn it all… (*He picks up the three francs from the table. To VICTOR.*) Alright! Here's three francs and don't let it happen again.

VICTOR: (*Dryly.*) Thank you. (*Pockets the money. Aside.*) What a pig!

REDILLON: (*Aside.*) Well, that's just the way I am! Generous to a fault!

VICTOR: Madame, I'll fetch the chambermaid so she can help me carry your trunk!

ARMANDINE: Very well. Off you go, young man!

VICTOR exits.

REDILLON: That'll teach him to be rude to me!

ARMANDINE: The poor little chap didn't mean it. He's not himself at the moment. He's not well.

REDILLON: I don't care if he's not well!

ARMANDINE: But if you knew what was wrong with him!

REDILLON: What is wrong with him?

ARMANDINE: He's got puberty, apparently.

REDILLON: Puberty! What do you mean, he's got puberty?

ARMANDINE: It's true! The doctor told him!

REDILLON: And that's his illness, is it? Ah, well, actually he has my sympathy!

ARMANDINE: Is it serious?

REDILLON: Puberty? Oh yes!

ARMANDINE: It's not catching, is it?

REDILLON: Unfortunately not! Good God! The germs would be worth a fortune!

VICTOR: (*Entering with CLARA.*) Come on, give me a hand.

CLARA: This trunk here?

VICTOR: Yes. It's got to go down to No. 17. (*He picks the bag from off the table.*) And the bag... (*They exit with the trunk and the bag.*)

REDILLON: Are you moving out?

ARMANDINE: Yes, I don't like this room. I've asked for one overlooking the street.

REDILLON: Overlooking the street? I don't see why that should be an improvement. Alright, let's go.

ARMANDINE: Us? What for?

REDILLON: What do you mean, what for? Now you are being stupid.

ARMANDINE: Oh! No, no, my friend. No, not tonight!

REDILLON: What?

ARMANDINE: There's no 'what' about it! It's quite impossible. I'm so sorry.

REDILLON: Ah, now this is serious. You've got a nerve! Do you expect me to leave just like that? With my tail between my legs?

ARMANDINE: There's nothing else for it! I'm expecting a friend at eleven o'clock.

REDILLON: A friend! What friend?

ARMANDINE: A gentleman from Zürich! Monsieur Soldignac. Each time he comes to Paris...

REDILLON: That's disgusting!

ARMANDINE: Too bad! He's coming anyway.

REDILLON: I know! Don't be here! Come to my place instead.

ARMANDINE: (*Brightening.*) Your place?

REDILLON: Yes, my place! I have a home, you know. I don't sleep in the gutter.

ARMANDINE: But what do we say to him?

REDILLON: Well... Look! Leave a message. Your mother's ill and you've gone to look after her. It's as old as the hills but it always works.

ARMANDINE: Oh? I don't think that's very nice.

REDILLON: Oh, but it is. It is. It's very nice. Here, put on your hat and I'll take you.

ARMANDINE: It's not nice but I'm tempted. (*A knock at the door.*)

REDILLON and ARMANDINE: Come in!

Scene 5

REDILLON, ARMANDINE, MANAGER, then PINCHARD, MME PINCHARD, then VICTOR.

MANAGER: (*Entering.*) I'm sorry to disturb Monsieur and Madame but the people who booked this room have arrived...

ARMANDINE: So you'd like us to push off?

MANAGER: Oh, I wouldn't put it like that.

ARMANDINE: I'll just put on my hat and then get out of the way! Could you ask the gentleman, whatever his name is...

MANAGER: Vatelin!

REDILLON: Vatelin?

ARMANDINE: Yes, to give me another couple of minutes.

REDILLON: I don't believe it! Vatelin! Here! What a coincidence! Show him in. I must just say hello!

ARMANDINE: Do you know him?

REDILLON: He's my closest friend.

MANAGER: (*To PINCHARD, in the corridor.*) If Monsieur would care to come in.

PINCHARD and MME PINCHARD enter.

REDILLON: (*To PINCHARD.*) Oh, my dear fellow! (*He embraces PINCHARD and then realises his mistake.*) Oh! I beg your pardon! (*Aside.*) That's funny. It's not the right one!

PINCHARD: (*While his wife acknowledges REDILLON and ARMANDINE.*) I'm so sorry, Monsieur and Madame. Didn't mean to turn you out. (*Aside.*) Dammit, what a fine looking woman! (*He gives his bag to his wife who puts it on the table. Aloud.*) I reserved a room for tonight by telegram and, as you see from their reply – 'Room 39 reserved for you' – this must be the one.

ARMANDINE: I should be apologising to you, Monsieur, for still being in it. We're just getting ready to leave.

PINCHARD: Take your time, Madame, I beg you! I wouldn't want to disturb you in the least. If there's room enough for two, there's room enough for four!

ARMANDINE: Oh Monsieur! You're so gallant!

PINCHARD: Not at all, Madame. (*To REDILLON.*) I must congratulate you, Monsieur. You have a jolly pretty wife. (*REDILLON bows.*) I'd swap yours for mine any day.

REDILLON and ARMANDINE: (*Astonished, staring at MME PINCHARD who is smiling and bowing.*) I beg your pardon! What!

PINCHARD: Oh, it's a fact! And I don't mind saying it in front of my wife.

REDILLON: And doesn't she mind you saying it in front of her?

PINCHARD: It's not that she doesn't mind. She's as deaf as a post.

REDILLON and ARMANDINE: Ha! Ha! (*They stifle their laughter.*)

MME PINCHARD: I beg you, Madame, don't put yourself out for us!

ARMANDINE: That's just what your husband was kind enough to say.

MME PINCHARD: (*Who has not understood.*) Nonsense, Madame, nonsense. Not in the least, Madame! Not in the least!

PINCHARD: Do you understand?

REDILLON: No.

PINCHARD: Neither do I. Her replies are often incoherent. But then, of course she hasn't heard a word.

MME PINCHARD: And my husband too. (*REDILLON looks baffled.*)

PINCHARD: There you are, you see! You have to get used to it! I've had to for twenty-five years. In fact it's twenty-five years ago today that we were married. We've come to Paris to celebrate our anniversary. I'm taking her to the Opera.

REDILLON: (*To ARMANDINE.*) He's taking a deaf woman to the Opera! (*To PINCHARD.*) You're going to the Opera? This evening? (*He looks at his watch.*)

PINCHARD: Yes. It's a little late. But after 'La Favorita' they're doing 'Coppelia'. We just want to catch the ballet. Music bores me but my wife only likes ballets. She watches them dance. It amuses her. Although she does admit it would be better with the music. Isn't that right, Coco?

MME PINCHARD: What?

PINCHARD: That you find the ballets short on music.

MME PINCHARD: Oh, much better. It's settled down now. It was the train upset it.

REDILLON and ARMANDINE exchange glances.

PINCHARD: Ah yes, now that's something else. As soon as you look at her she starts talking about her stomach. She gets these slight liver attacks. But she's better now. (*To MME PINCHARD.*) Yes, MUCH better now. Splendid, splendid! (*To REDILLON.*) She's a bit incoherent. But you have to get used to that. Have to get used to that!

ARMANDINE: Well, Monsieur, I won't keep you any longer! Are you ready, Ernest? (*To PINCHARD.*) Monsieur... (*She moves to the door.*)

PINCHARD: (*Bowing.*) Madame, delighted. Monsieur, a pleasure.

REDILLON: Oh Monsieur, the pleasure's all mine, believe me. There's just one thing I'd like to tell you.

PINCHARD: What's that, Monsieur?

REDILLON: You'll never believe it but my best friend's name is Vatelin.

PINCHARD: (*Nonplussed.*) Really?

REDILLON: Yes.

PINCHARD: Really… Good God! (*A pause.*) Monsieur, one confidence deserves another. My best friend's name is Piedlouche.

REDILLON: (*Equally nonplussed.*) Really?

PINCHARD: Yes.

REDILLON: Really! (*A pause. Then, aside.*) What does he think that's got to do with me?

PINCHARD: Well, it's been a pleasure, Monsieur. I can't thank you enough.

REDILLON: Monsieur!

REDILLON and ARMANDINE: (*To MME PINCHARD.*) Madame!

PINCHARD: (*Giving his wife a tap on the arm.*) Coco! (*MME PINCHARD turns towards them.*) Monsieur and Madame are saying good-bye.

MME PINCHARD: (*Shouting.*) What?

PINCHARD: (*Shouting.*) Monsieur and Madame are saying good-bye!

MME PINCHARD: I can't hear!

PINCHARD: I know you can't! You silly old… Wait! (*He mouths the words without making them audible.*) Monsieur and Madame are saying good-bye.

MME PINCHARD: Oh, I'm so sorry! Good-bye, Madame. Good-bye, Monsieur.

REDILLON: (*To ARMANDINE.*) Now isn't that odd? She can only hear when *we* can't.

PINCHARD: Right!

ARMANDINE: Are you coming, Ernest?

REDILLON: Right! (*A knock at the door.*)

ALL: (*Except MME PINCHARD.*) Come in!

VICTOR: (*Entering, to ARMANDINE.*) Madame has nothing more to go?

ARMANDINE: No thank you, young man. Tell them downstairs that if a gentleman calls for me, they're to say I couldn't wait. I've been called away to my mother who's sick. Do you understand?

VICTOR: (*With a sigh.*) Yes, Madame.

ARMANDINE: Off you go then, young man. And get better soon.

VICTOR: Thank you, Madame.

PINCHARD: Is he ill?

ARMANDINE: Yes, he's got boils. Take care of yourself. (*To REDILLON.*) Come on, we must go. (*As she's going out, to REDILLON.*) Oh, my bag!

REDILLON: Yes, yes. (*To VICTOR.*) The bag over there!

VICTOR: Here it is. (*He takes PINCHARD's bag from the table and gives it to REDILLON. The PINCHARDS do not notice.*)

REDILLON: (*Taking the bag. Aside.*) Strange bag for a lady! Oh well, alright… (*He follows ARMANDINE out.*)

MME PINCHARD: Well, I must get ready if we're going to the Opera. (*She goes into the bathroom.*)

PINCHARD: That's right. (*To VICTOR.*) Well, what's keeping you? Have you taken root?

VICTOR: Monsieur?

PINCHARD: So you've got boils have you?

VICTOR: Yes, Major. But nothing serious.

PINCHARD: I know that! Seen plenty of 'em in my time as a Medical Officer in the cavalry. Come on. Let's have a look.

VICTOR: Yes, Major. I think I caught them from…

PINCHARD: Cut the chat and drop your trousers. (*MME PINCHARD comes in from the bathroom.*)

VICTOR: Eh, Major?

PINCHARD: Don't you understand? I said, 'Drop your trousers.'

VICTOR: (*Taken aback. Indicating MME PINCHARD.*) But Monsieur…

PINCHARD: What? Are you embarrassed by my wife? Pay no attention. She's deaf.

VICTOR: Oh good! (*He looks, puzzled. Puts his hand on the belt of his trousers, then hesitates.*)

PINCHARD: Well? What are you waiting for?

VICTOR: Well, Monsieur. I was going to say that if you just want a look – out of curiosity – that's fine by me. But if you want to see the boil, it's actually on my neck.

PINCHARD: On your neck ? What are you blithering about? No boil on your bum? No boil on your bum? Then what's the problem? A boil on the neck don't make you unfit for duty. You want to be excused parade for a boil on the neck? (*He advances on VICTOR.*) You deserve to be put on a charge for shirking. No boil on the bum, indeed!

VICTOR: But Monsieur…

PINCHARD: Alright. On your way! Dismiss! At the double!

VICTOR: Yes, Monsieur! (*Aside, as he exits.*) Got a right one here!

PINCHARD: What a carry-on! For a boil on his neck!

MME PINCHARD: At half past ten. You don't have much time.

PINCHARD: I'm not talking about that. I'm talking about his boil.

MME PINCHARD: Look at the prograrnme. You'll see.

PINCHARD: Yes alright. I'll get ready. Where's the bag? (*Shouting.*) Where is the bag?

MME PINCHARD: What?

PINCHARD: (*Mouthing the words without speaking.*) Where is the bag?

MME PINCHARD: (*Serious.*) Where is the bag? You were carrying it.

PINCHARD: (*Shouting.*) I was carrying it? (*Mouthing.*) I was carrying it?

MME PINCHARD: Absolutely! Where have you put it?

PINCHARD: (*Aside.*) Oh, she's a great help, she is! Where can I have hidden it? (*A knock at the door. Aloud.*) Come in!

PINCHARD looks under the table. MME PINCHARD looks under the armchair.

Scene 6

PINCHARD, MME PINCHARD, CLARA.

CLARA: (*Entering.*) I've come to turn down the bed. Are Monsieur and Madame looking for something?

PINCHARD: Yes. A travelling bag. Damnation!

MME PINCHARD: (*To PINCHARD.*) Perhaps the little page-boy put it in the bathroom?

PINCHARD: You think so? I'd have seen him, wouldn't I? (*He goes into the bathroom.*)

CLARA: (*To MME PINCHARD.*) What pillows docs Madame prefer? Feather or horsehair? (*No reply from MME PINCHARD.*) What pillows do you prefer, feather or horsehair? (*No reply.*) Really! What's the matter with her? She's in a dream. (*Standing in front of her.*) Does Madame prefer...?

MME PINCHARD: (*Startled.*) Oh! Good evening, young lady.

CLARA: (*Following her.*) Good evening, Madame. I was just asking Madame if she preferred...

PINCHARD: (*Re-enters, still searching for his bag.*) Yes well, don't bother. You're wasting your time. I must have left it downstairs at the desk. What were you asking her?

CLARA: I wanted to know, Monsieur...

PINCHARD: (*Looking at her for the first time.*) By Jove! You're a pretty girl!

CLARA: What pillows you prefer, feather or horsehair?

PINCHARD: Yes I must say, you're really damned attractive!

CLARA: What? I was just asking Monsieur...

PINCHARD: Whatever you like – feathers or horse-hair. How about sharing your pillow? That's what I'd really like.

CLARA: (*Scandalised.*) Really, Monsieur!

PINCHARD: Come on, what's your name, my dear?

CLARA: What's yours, darling?

PINCHARD: Darling! (*Aside.*) Ah ha! She called me darling!

CLARA: (*Moving towards the bed.*) Well, you started it. Being familiar. (*She turns down the cover.*)

PINCHARD: (*Moving towards her.*) No need to be formal, my dear. (*Holding her waist.*) Ah! You called me darling!

CLARA: (*Disengaging herself.*) Will you leave me alone, Monsieur! (*Calling.*) Madame! Madame!

PINCHARD: That's right. Call as loud as you like.

CLARA: (*To MME PINCHARD.*) Will you please keep your husband under control!

MME PINCHARD: In Paris? Yes, until tomorrow.

CLARA: Oh! She's deaf!

PINCHARD: As a post. But you're adorable! (*He kisses her.*)

CLARA: (*She hits him hard in the stomach.*) Take that!

PINCHARD: Oh!

MME PINCHARD: (*Turning round.*) Well? Have you got it?

PINCHARD: (*Clutching his stomach.*) Yes, I got it alright!

CLARA: Is there anything else I can do for Monsieur?

PINCHARD: No! No, no, thank you. (*Aside.*) Little minx. God, she packs a punch!

MME PINCHARD: Have you got stomach ache?

PINCHARD: No no, it's nothing. (*To CLARA.*) Tell them downstairs to send up my bag. I must have left it at reception. See that it's here when I get back.

CLARA: Certainly, Monsieur.

PINCHARD: (*To MME PINCHARD.*) Come along, Coco! (*Mouthing.*) Come along.

MME PINCHARD: Do let's go. I'm ready.

PINCHARD: Off we go. 'La Favorita' must be over now.

MME PINCHARD: (*Who hasn't heard.*) What's 'La Favorita' about?

PINCHARD: A prostitute.

MME PINCHARD: Oh, I don't approve of women like that.

PINCHARD: They fill a need, my dear Coco. They fill a need. (*They exit.*)

Scene 7

CLARA, then PONTAGNAC.

CLARA: (*Alone.*) Share my pillow indeed! Did he really think that if I'd wanted to leave the straight and narrow, I would have chosen him as my escort! No, really!

PONTAGNAC: (*Putting his head round the door. He carries a small parcel. Aside.*) I was right. I thought I heard someone go out. Vatelin's taken this room for the night. He'll be here any minute. I must get things organised. The key!

CLARA: Do you want something, Monsieur?

PONTAGNAC: (*Aside.*) Damn! The maid!

CLARA: Do you want something, Monsieur?

PONTAGNAC: (*Aloud.*) Me... er? Do I want something?

CLARA: Yes.

PONTAGNAC: Yes... The King of the Belgians!

CLARA: Well, he's not here.

PONTAGNAC: Ah! Not here is he?... Ah! Pity!... Oh well, I thought as much.

CLARA: Well then...

PONTAGNAC: I knew the room was right. Room 39. Only I said to myself, is this the right hotel? Well, clearly it's not!

CLARA: I hope that's your only mistake.

PONTAGNAC: Yes. Let's hope so. When I saw the King today he said: 'My dear fellow, we're staying at the Ultimus, Room 39'. Now I'm positive about the room number. But the Ultimus? With that accent! I heard the Ultimus, but he might well have said the Continental.

CLARA: You move in royal circles, Monsieur?

PONTAGNAC: Yes, yes. A minor minister of no importance. So you see to be near him, I took Room 38... (*Approaching the door to Room 38.*). This Room 38, the one through here.

CLARA: Yes, I see.

PONTAGNAC: (*Nearly at the door.*) It's through here. Number 38.

CLARA: Yes, I know. (*She goes over to the bed.*)

PONTAGNAC: (*Taking the key. Aside.*) There! I've got the key! (*Aloud.*) Oh well! If he's not here, he's not here. So many matters to discuss... Nothing at all, actually. Your servant, Mademoiselle. (*He goes out, while CLARA looks bewildered.*)

Scene 8

CLARA, then PONTAGNAC, LUCIENNE.

CLARA: Minor minister indeed! Right, I'd better fetch those pillows. (*She goes out. A key is heard in the door to Room 38 and PONTAGNAC, followed by LUCIENNE, comes in immediately.*)

PONTAGNAC: You can come in. She's gone!

LUCIENNE: So… This is it?

PONTAGNAC: This is it.

LUCIENNE: It will be in this room?

PONTAGNAC: Number 39! Precisely!

LUCIENNE: Oh, what depravity! And to think that at any moment, in this room, my husband and another woman…

PONTAGNAC: Yes, another woman…

LUCIENNE: Yes. The two of them. Him – the man I know intimately, with his sweet words and tender caresses. And her – a woman I don't know at all. With her, he'll… Oh, I can't bear to imagine it. And then…? Oh, no, I can't, I won't…! Oh God! And you! You're just going to stand there and watch in cold blood.

PONTAGNAC: Well… Providing they are good at it…

LUCIENNE: Oh, shut up! I can see it all! Dreadful images appear before my eyes. Oh no, no, no. I won't have it! I won't! The maid, ring for the maid.

PONTAGNAC: The maid! What for?

LUCIENNE: I'm going to have the bed removed.

PONTAGNAC: Oh no, no. You're not thinking. Do you want to catch your husband or don't you?

LUCIENNE: Oh, yes I do. Of course I do!

PONTAGNAC: Well, then... if you want physical proof, don't remove his means of supplying it.

LUCIENNE: But you're putting me through the most frightful ordeal.

PONTAGNAC: I'll try not to prolong it unnecessarily.

LUCIENNE: Please don't!

PONTAGNAC: Providing we get to the critical moment.

LUCIENNE: Before then! Before the critical moment.

PONTAGNAC: Well, yes, that's what I mean. Not too early, before the fiddles have had a chance to tune up. But not too late...

LUCIENNE: After the conductor has raised his baton.

PONTAGNAC: Precisely.

LUCIENNE: Yes, yes. But how will we know?

PONTAGNAC: Ah well, I've already thought of that. Here's how. Right here.

He unwraps a package.

LUCIENNE: Whatever's that? Electric bells!

PONTAGNAC: Correct. Have you ever heard of fishing with bells?

LUCIENNE: No.

PONTAGNAC: Well, this is what it is – fishing with bells. You put a bell on the end of a line and the fish rings it himself to announce that he's been caught. I'm applying the same technique to Vatelin.

LUCIENNE: You're going to fish for my husband with a bell?

PONTAGNAC: Correct. Then he and his... companion will oblige by ringing us at exactly the right moment.

LUCIENNE: Oh, come on! What nonsense!

PONTAGNAC: Nonsense? Just wait. I'll show you how simple it is. (*Moving to the bed.*) Which is your husband's usual side?

LUCIENNE: The outside.

PONTAGNAC: The outside? Good! So the lady will be on the inside. The outside, the inside! Good. So I take these two electric bells. The big one here... (*He rings a bell – it has a deep tone.*) Let's make that one Vatelin's! And this one here... (*He rings the other bell – it has a high pitched tone.*) That will be for Madame! (*Ringing them one after the other.*) Monsieur, Madame! (*He rings them again.*) Monsieur, Madame! Good! I put Monsieur here! (*He slips the first bell under the mattress in VATELIN's place. Moves round to the other side of the bed.*) And Madame here! (*He slips the bell under the mattress.*)

LUCIENNE: And then?

PONTAGNAC: Then? Then there you are! The line is baited.

LUCIENNE: And that's it?

PONTAGNAC: Yes! All we have to do is wait for a bite. One of them slips into bed. The bell rings instantly. We don't move. Only one fish has been caught. All of a sudden, number two arrives and the couple is complete. The other bell rings and there we are! We've got them both!

LUCIENNE: That's very clever.

PONTAGNAC: More than clever. Inspired! I'm a genius, that's all.

Sound of voices.

PONTAGNAC: I hear voices. Perhaps it's them.

LUCIENNE: Them! I'll tear their eyes out!

PONTAGNAC: Now, now! They haven't even begun and you want to tear their eyes out! Quick, come on. We've no time to lose.

LUCIENNE: Crépin, your time is running out!

They go out into Room 38, locking the door after them.

The door at the back opens and MITZI enters, followed by CLARA carrying two pillows.

Scene 9

MITZI, CLARA, then VATELIN, VICTOR.

MITZI: Bitte, I'm asking you for Room 39. Is this Herr Vatelin's room? (*She puts her bag on the table.*)

CLARA: Madame, I've told you that in the guest's absence, I cannot permit anyone to enter his room unless the guest has given me express instructions to do so.

MITZI: Gott im Himmel! He told me to wait if he wasn't here. He even sent me a telegram. (*Hands CLARA the telegram.*)

CLARA: (*Reading.*) 'Your husband knows everything. He found the letter in the wastepaper basket...'

MITZI: (*Quickly.*) Ach no, that's not for you, that's for me! (*She takes the telegram, folds over the top and gives it back to CLARA.*) Nein, read the end: 'Come to the Hotel Ultimus.'

CLARA: (*Reading.*) 'Ask for my room and if I'm not there, wait for me. Vatelin.'

MITZI: (*Taking back the telegram and pulling out of her bag a bathrobe, a bag of coffee beans, a percolator and a grinder.*) Also bitte. Does that convince you?

CLARA: Very well, Madame, you may wait.

MITZI: Where is the bathroom?

CLARA: (*Opening the bathroom door.*) In here, Madame.

MITZI: (*Picking up her nightdress and nightcap.*) Will you bring cups and some hot water for my coffee?

CLARA: Yes, Madame.

MITZI: And some plates. And forks, perhaps. For my Kuchen.

CLARA: What?

MITZI: (*Screaming.*) Kuchen!

CLARA: Bless you!

MITZI: Thank you!

MITZI goes into the bathroom. VATELIN enters from the corridor with VICTOR.

VICTOR: Here's your room, Monsieur.

VATELIN: (*A bag in his hand.*) Ah, very good.

CLARA: (*To VICTOR.*) You've made a mistake. This room's taken... by a Monsieur Vatelin.

VATELIN: But that's me. I'm Monsieur Vatelin.

CLARA: But there were two people here just now who –

VATELIN: (*Putting his bag down.*) Don't worry about them. They should be in No. 59, but the telegram confirming the booking said 39 by mistake. They've made a note at reception to tell them when they come back.

CLARA: Oh, that's alright then.

VATELIN: Thank you, my boy. And just let them know downstairs that a lady will be asking for me. They should give her my room number and show her up.

VICTOR: Very good, Monsieur. (*He exits.*)

CLARA: Monsieur is looking for a lady?

VATELIN: No thank you. I've more than I need.

CLARA: Oh, but Monsieur, I'm not offering you one! A lady was asking for Monsieur just now. She's in there.

VATELIN: She's here! Already!

CLARA: Shall I tell her?

VATELIN: No, no. Leave her. She's fine where she is.

CLARA: Very good, Monsieur. I'll fetch the hot water. (*She exits.*)

Scene 10

VATELIN then MITZI.

VATELIN: Yes, she's fine where she is. I'll see her soon enough. Oh, look at the state I'm in! (*MITZI is heard singing a German song.*) That's her…

MITZI: (*Entering.*) Crépine! You're here! Aach, meine kleine Schatzeleine! How happy I am! (*She throws her arms round his neck. VATELIN averts his face.*) What? Don't you want me to kiss you?

VATELIN: No!

MITZI: Nein?

VATELIN: No. You wanted me to come. I have come. In order to avoid a scandal at home and stop you

doing something rash, I gave in. But please get it into your head that everything's over between us.

MITZI: Oh Crépine, why do you say such things? It's so cruel. I loved you because you're so tender and gentle. You're not like my brute of a husband.

VATELIN: (*Aside.*) Oh, so that's why you loved me! Ah ha... Well, just you wait!

MITZI: You're the perfect gentleman with women.

VATELIN: Am I? Ah well, I'm afraid that's where you're wrong! You thought I was a gentleman, did you? Oh well... Well, I'll be blowed! I'll be damned! No, I'll be bloody well damned! There! I'll show you just how gentle I am. (*With a noisy shout, he jumps in the air and pretends to hit her.*) There – that's the sort of gentleman I am!

MITZI: (*Laughing.*) Oh, you're really very funny!

VATELIN: Funny! You think I'm funny do you? Ah, you don't know the real me. I'm not nice, I'm not gentle, and I'm not kind. In Zürich perhaps, when I was away from home. But in France I'm hot-tempered, brutal and violent!

MITZI: You?

VATELIN: Yes. And I beat women too. (*He pretends to thrash her.*) Arh! arh! arh!

MITZI: (*Nearly collapsing with laughter.*) Oh, Crépine!

VATELIN: Come any nearer and I'll hit you!

MITZI: (*Taking up the challenge.*) What did you say?

VATELIN: (*More timidly.*) I said, if you come any nearer I'll hit you.

MITZI: Hit me, will you?

VATELIN: Absolutely.

MITZI: Just you try…

VATELIN: There!

He thumps her gently. MITZI fells him with a punch.

MITZI: So you enjoy a fight do you? You filthy, filthy frog. I adore you! (*She seizes him round the neck from behind, and kisses him. A knock at the door.*) Come in!

Scene 11

MITZI, VATELIN, CLARA.

CLARA enters with a tray. MITZI and VATELIN get up.

CLARA: Here's the hot water.

MITZI: Ah good. Put it down there (*She disentangles herself from VATELIN.*) Thank you. Raus! (*CLARA exits.*) Well! (*She grinds the beans loudly and puts the coffee in the percolator.*) Do you still want to hit your little Mitzi?

VATELIN: You are mad, woman! Will nothing stop you? Look, you know your husband smells a rat.

MITZI: Smells a what?

VATELIN: (*Exasperated.*) It's just an expression! He suspects something, if you prefer. If it hadn't been for my telegram…

MITZI: Ach ja! My head… Straight in the lion's beak!

VATELIN: Quite! (*Exasperated again.*) Only one says mouth, not beak. Lion's mouth. A lion doesn't have a beak. Just a small observation… en passant. (*Hysterical.*) What does it matter!! I can't play the part you want. I simply can't! And if you won't be reasonable, then I must… on your behalf. Good-bye!

MITZI: Crépine! Crépine! Stay! Oh, do stay!

VATELIN: No. Let go. Let go of me!

MITZI: Nein.

VATELIN: No?

MITZI: Alright! I'll kill myself!

VATELIN: Oh my God, not again! This is blackmail! Alright. Go ahead. Kill yourself and leave me in peace!

MITZI: Very well. First, eine tasse kaffee. Then einen kleinen kuchen. And then death! (*She pours a cup of coffee.*)

VATELIN: Well, go on then! Get on with it!

MITZI: Will you have a cup?

VATELIN: What?

MITZI: I said, will you have a cup? Of coffee.

VATELIN: Oh, alright then.

MITZI pours a cup and hands it to him.

MITZI: One lump? Or two?

VATELIN: Four.

MITZI: That's quite a lot.

VATELIN: (*Stirring his coffee.*) So?

MITZI: (*Taking a small flask from her pocket.*) One drop? Or two?

VATELIN: I don't know. Whatever you like. Give me a spoonful.

MITZI: Himmel! That really is a lot! (*Pouring.*) A spoonful. Enough to finish off a regiment.

VATELIN: Eh? What is it?

MITZI: Strychnine. (*She puts the flask to her lips.*)

VATELIN: (*Trying to grab the flask.*) Put that down!

MITZI: Nein! I want to drink the lot and die at your foot!

VATELIN: Mitzi! I beg you!

MITZI: (*Trying to raise the flask to her lips.*) Nein! Auf wiedersehen, Crépine!

VATELIN: (*Preventing her.*) Mitzi, I will be nice. I'll do anything you want! Anything you want! There…!

MITZI: Oh, you're just saying that!

VATELIN: No, no! Anything! Anything! I swear it!

MITZI: Ja?

VATELIN: Yes…! Ja…! Yes…! Jawohl!

MITZI: Ach! Das ist aber besser. (*She puts the flask in her pocket.*)

VATELIN: (*Aside.*) Right…! If it's got to be done, I might as well get on with it. (*Aloud, trying to work himself up.*) Yes, yes, you're right. We've fought enough… Come, Mitzi, come! I want you, I lust after you. Ah, come, come to me! (*He takes her in his arms and tries to drag her towards the bed.*)

MITZI: (*Frightened, breaking away from him.*) Ach, nein, nein, Crépine. Not like this, please!

VATELIN: Oh. Let's forget it then.

MITZI: No, no, Crépine. Alright. I will. I will.

VATELIN: I've rather gone off it now.

MITZI: Oh, nein! Sssh! Sssh! You love me, I love you!

VATELIN: We love each other!

MITZI: Wait… I'm going in there. (*She goes towards the bathroom.*)

VATELIN: In there?

MITZI: Ja. You don't want me all dressed up like this, do you?

VATELIN: Ah! Right! But couldn't you undress here?

MITZI: Oooh! Here! In front of you! Naughty boy! (*MITZI exits.*)

Scene 12

VATELIN, then LUCIENNE, PONTAGNAC, SOLDIGNAC.

VATELIN: Oh my God! I'm not really up to this. Jump in bed? I'd sooner jump in the river! (*He sits on the bed, lost in thought. The bell under the mattress rings. A long pause while he listens.*) Extraordinarily noisy bells in this hotel!

The door to Room 38 opens noiselessly and LUCIENNE puts her head round. Recognising her husband's back, she raises her arms to heaven and opens her mouth. PONTAGNAC enters, puts his hand over her mouth and shakes his head – there is only one person there. He pulls her out and swiftly closes the door. The business is silent and speedy.

(*Turning round suddenly.*) Hello? (*He sees no-one. Aside.*) Nobody there! I must have imagined it! I'm sure I heard something. (*Going to inspect the door to Room 38.*) No, that's closed. And locked. I must have dreamt it. How odd! I thought I felt a draught from the door. And as for that damn Mitzi and her strychnine coffee! (*Going to ring the bell.*) I'll get them to take the filthy stuff away, (*He rings.*) before she has another of her mad whims… (*A knock at the door.*) Ah good. That chambermaid's fast on her feet. (*Aloud.*) Come in!

SOLDIGNAC: (*Entering.*) Hello!

VATELIN: (*Aside.*) Soldignac! Good grief! Her husband! (*Aloud.*) Ah, ha! It's you!

SOLDIGNAC: Ja. It's me!

VATELIN: Ah, ha, ha, ha! Really... Well, well. What are you doing here?

SOLDIGNAC: Ah, that puzzles you, does it?

VATELIN: (*Aside.*) Oh my God, and his wife's in there!

SOLDIGNAC: I was downstairs in reception when the pageboy came along with your message: if anyone asks for Monsieur Vatelin, show them up to No. 39.

VATELIN: (*Aside.*) Well, that was really bright of me.

Sneaks towards the bathroom door. SOLDIGNAC seizes VATELIN's arm. Throughout the scene, VATELIN tries to get near the bathroom door.

SOLDIGNAC: As it happens, I also came to this hotel for a rendez-vous with a lady. But she couldn't wait and has begged me to excuse her.

VATELIN: (*Distractedly.*) Yes, yes, yes.

SOLDIGNAC: She's had to go and look after her mother who's very sick. (*Fuming at VATELIN.*) Aren't you interested in what I'm saying?

VATELIN: Very much so! I'm following every word! Sick, you said. I'm so pleased. Are you sick?

SOLDIGNAC: Who?

VATELIN: You!

SOLDIGNAC: No. Not me. Her!

VATELIN: Ah! Her!

SOLDIGNAC: Ja... Her mother.

VATELIN: Ah, her mother! The old lady. Yes, of course. She's sick.

SOLDIGNAC: So what am I to do? I suppose you'd say that I could just go.

VATELIN: (*Taking him to the door.*) Eh! By all means! Go on, then. Off you go. Never mind me.

SOLDIGNAC: Ach nein, nein! I was just supposing...

VATELIN: Oh, you were just supposing. (*Aside.*) Pity! (*Aloud.*) No. I said that because I know you're normally in such a rush.

SOLDIGNAC: Ach ja! During the day. Geschäft. But during the evening, I have plenty of time.

VATELIN: (*Aside.*) This is going to be fun!

SOLDIGNAC: Anyway, I can't just go. As I knew I'd be at the hotel this evening, I arranged to meet the Inspector of Police here.

VATELIN: Police? Here?

SOLDIGNAC: Yes, of course. You know very well it is tonight that I catch my wife.

VATELIN: (*Aside.*) My God! Does he suspect? (*Aloud.*) She's not here! She's not here!

SOLDIGNAC: Who? My wife? I know that. She's at the Rue Rockerpiner.

VATELIN: Ah, yes, yes. (*Aside.*) He suspects nothing!

SOLDIGNAC: The Inspector should be catching her in the act at this very moment.

VATELIN: (*He moves towards the bathroom.*) Yes, yes, yes, yes, yes.

SOLDIGNAC: Just to make absolutely sure, he's had someone on her tail all day. (*VATELIN freezes.*) Aren't you interested in what I'm saying?

VATELIN: Oh, yes, yes, of course! You were just saying, 'Sick, she's sick.'

SOLDIGNAC: Aber nein! Not any more!

VATELIN: Oh, so she's dead! Well... that's often the next step.

SOLDIGNAC: Aber nein! I was saying that my wife –

VATELIN: Ah, yes, your wife. There she is!

SOLDIGNAC: Where?

VATELIN: There she is. Over in the Rue Roquépine!

SOLDIGNAC: Ja! He had her followed.

VATELIN: (*More and more agitated.*) Followed? Did he?

SOLDIGNAC: As soon as he's caught her, the Inspector will send me word.

VATELIN: Really! Splendid! Splendid!

The bathroom door opens. MITZI's arm appears. She drops her bodice on the floor and withdraws her arm.

SOLDIGNAC: (*Who has seen it.*) Oooh! Pretty! Very pretty!

VATELIN: Did you see that? That, er... That is an arm.

SOLDIGNAC: Ho-ho. Oh, I saw! Very pretty. You old rogue! Whose arm is it?

VATELIN: I don't know. It doesn't belong here. It's an arm from over there. Which just appeared, briefly, here. It's the woman's next door.

SOLDIGNAC: Rubbish! It's your woman's arm.

VATELIN: Ah yes, it's my woman's arm. The woman next door is my woman. She's not really my woman, she's your wife – I mean my wife! The woman next door is my wife. (*He picks up MITZI's bodice. MITZI's arm reappears holding her skirt. VATELIN rushes over, snatches the garment, then drops to the floor, cramming bodice and skirt under the bed.*)

SOLDIGNAC: Your wife. Well, well, my dear fellow. (*Unable to see VATELIN.*) But where have you gone?

VATELIN: (*Jumping up from behind the bed.*) Here I am! Here I am!

SOLDIGNAC: Sit yourself down here next to me.

VATELIN: (*Aside.*) Look at him. Settled in for the night.

SOLDIGNAC: My compliments! That's quite an arm she has, your wife.

MITZI, unaware that her husband is there, enters from the bathroom. She wears a dressing gown and night-cap. Seeing her husband, she screams, and rushes back into the bathroom. SOLDIGNAC turns, but VATELIN catches his head in his hands and brings them back face to face.

SOLDIGNAC: Ach! What are you doing?

VATELIN: I'm so sorry. My wife wasn't dressed.

SOLDIGNAC: What? Aah! Yes, yes... I beg your pardon. Oooh, you did the right thing.

VATELIN: I should say so. How about a game of billiards?

SOLDIGNAC: Ach ja! I'd like that. Very much.

VATELIN: (*Aside.*) It's the only way to get rid of him.

SOLDIGNAC: Besides, we must be embarrassing the lady.

VATELIN: (*Aside.*) I'll just play a couple of frames, then leave. (*Aloud.*) Let's go.

SOLDIGNAC: Yes, let's go.

A knock at the door.

VATELIN: Who is it now?

SOLDIGNAC: Come in!

VATELIN: (*Aside.*) Come in! He's got a cheek!

Scene 13

VATELIN, SOLDIGNAC, REDILLON, then CLARA.

REDILLON: (*Entering, carrying PINCHARD's bag.*) I beg your pardon, Messieurs.

VATELIN: Rédillon! Here!

REDILLON: I must have taken the wrong bag just now. (*Recognising VATELIN.*) Ah! Vatelin! You're here? (*He puts the bag down.*)

VATELIN: Um, yes. It's me. I missed the train. I'll explain later… I know! Go and have a game of billiards with this gentleman.

REDILLON: With Monsieur? But I don't know him.

VATELIN: Soldignac, Rédillon. Rédillon, Soldignac. Now go and have a game of billiards!

REDILLON: Me? But I don't play billiards!

VATELIN: Never mind. He does. He'll show you.

REDILLON: No, he won't! Besides I'm in a hurry! Someone's waiting for me. (*He sits down.*)

VATELIN: Well, don't sit down then. It's not worth it. We're going downstairs. (*He pulls him up.*)

REDILLON: Oh, alright…! Would you believe it, I –

VATELIN: No. No, we haven't got time! Where's my hat?

REDILLON: (*Aside.*) What on earth's the matter with him? He's making me uncomfortable. (*He's about to drink from the cup of coffee.*)

VATELIN: (*Putting on his hat.*) Got it. There we are. Let's go.

SOLDIGNAC: Let's go.

VATELIN: (*Pulling the cup away from REDILLON.*) No!!! Don't drink that! We haven't time.

A knock at the door.

SOLDIGNAC: Come in!

VATELIN: Not again! He's getting on my nerves!

CLARA: (*Entering.*) You rang, Monsieur?

VATELIN: Yes, I did. Take the tray away. (*He pulls the cup away again from REDILLON who was about to drink it, and gives the tray to CLARA.*)

CLARA: Very good, Monsieur. (*She exits with the tray.*)

VATELIN: Now let's go.

SOLDIGNAC: Let's go.

REDILLON: The bag! I came to fetch the bag!

VATELIN: (*Handing Rédillon the bag he's just brought back i.e. PINCHARD's.*) Here. Take your bag and come along.

REDILLON: No, not this one! That's the one I brought back.

VATELIN: (*Handing him MITZI's bag.*) How about this one?

REDILLON: (*Taking the bag.*) I'm not sure. Isn't it yours?

VATELIN: No. (*He puts PINCHARD's bag on the table in place of MITZI's.*)

REDILLON: Then it must be this one. Let's go! (*He moves upstage.*)

SOLDIGNAC: (*Also moving upstage.*) Let's go!

VATELIN: Right! You go on ahead. I'll have a quick word, and catch you up.

REDILLON and SOLDIGNAC exit.

Scene 14

VATELIN, MITZI, then PINCHARD, MME PINCHARD, VICTOR

VATELIN: (*At the bathroom door.*) Quick, Mitzi!

MITZI: (*Entering.*) Can I come out? Have they gone?

VATELIN: They're waiting for me outside! I've got to go and play billiards with your husband. For safety's sake I'll lock you in and take the key. Now, if anyone should come, hide in the bathroom and stay there until I come back to fetch you. Alright?

MITZI: Ach, jawohl!

SOLDIGNAC's VOICE: Vatelin! Vatelin!

VATELIN: (*Quickly.*) It's him. Hide!

MITZI hides in the wardrobe.

SOLDIGNAC: (*In the doorway.*) Vatelin! Do come along.

VATELIN: Here I am. I'm coming, I'm coming. (*He goes out, double-locking the door behind him.*)

MITZI: (*Coming out of the wardrobe.*) Oh, I'm so frightened! Oh, God, when I saw my husband there, all my courage vanished. Oh, no, no. I can't go on with it. I want to get

out. (*She looks for her dress on the chair.*) My dress! Where has he put my dress? (*Voices offstage.*) Oh, my God, what's happening now? (*She rushes back into the wardrobe.*)

PINCHARD's VOICE: Damnation! The key's not in the door and I forgot to ask for it downstairs. (*Calling.*) Boy! Open the door for me, please.

VICTOR's VOICE: Certainly, Monsieur!

The key turns in the lock. The door opens and PINCHARD and MME PINCHARD enter. VICTOR stands aside.

PINCHARD: Thank you, my boy.

VICTOR: Not at all, Monsieur. (*He exits.*)

PINCHARD: (*Supporting his wife.*) There, there. Don't whine. It'll pass. Come on, sit down here. (*Aside.*) Damn these liver attacks! It would have to come on again in the theatre. We had to leave before the end. (*Spotting his bag. Aloud.*) Ah, they've brought up my bag. I knew I must have left it downstairs. (*He mouths to MME PINCHARD.*) Now then, aren't you feeling any better? (*MME PINCHARD shakes her head.*). Still poorly? (*MME PINCHARD nods.*) Show me your tongue. (*MME PINCHARD puts out her tongue.*) Not too bad. (*MME PINCHARD pouts.*) You ought to be in bed you know.

MME PINCHARD: Do you think so? Perhaps you're right.

PINCHARD: But of course I am.

MME PINCHARD: Goodnight.

PINCHARD: Goodnight! (*MME PINCHARD moves away, then returns to her husband and kisses him twice.*) Ah yes, our anniversary. (*He kisses her on the forehead.*). Twenty-five years! (*She starts to undress.*) I'll make up a sleeping draught for her. (*He looks in his bag.*) Where's my

medicine chest? (*Pulling out his slippers.*) My slippers!
(*He throws them in front of him, and pulls out another pair.
Aloud.*) Here you are, Coco. Your slippers! Hey!
Slippers! (*He throws them over to his wife.*)

MME PINCHARD: (*Behind the bed.*) Thank you. And my
bed-jacket.

PINCHARD: (*Taking a bed-jacket out of the bag.*) Ah!
Bed-jacket! (*To his wife.*) Bed-jacket! (*He throws her the
bed-jacket. She puts it on. He opens the travelling medicine chest.
Aside.*) Laudanum. Laudanum. Where's the bloody
laudanum. Ah, here we are! (*He takes the glass, carafe, and
spoon.*) Now then, let's get this made up. (*He mixes the
solution.*)

*MME PINCHARD, in her petticoat, her hair loose, sits on the
bed to comb it. The bell rings. PINCHARD pays no attention.*

PINCHARD: (*Counting the drops.*) One, two, three… Oh,
what joker is ringing like that at this hour? Four,
five, six. There we are, six drops. (*He puts the glass on
the table.*) Oh, this is getting on my nerves. (*He runs to
the door and shouts down the corridor.*) Will you stop
ringing that damn bell!

MAN IN THE CORRIDOR: Really! Who's ringing
like that?

PINCHARD: (*Replying.*) I don't know, Monsieur. It's
intolerable. (*Shouting.*) That's enough! People here are
trying to sleep!

MME PINCHARD: (*Getting up. The ringing stops.*) What on
earth's going on?

PINCHARD: (*No longer hearing the bell.*) Oh, it's stopped.
And not a moment too soon.

MAN IN THE CORRIDOR: Yes. About time.
Goodnight, Monsieur.

PINCHARD: Goodnight.(*He shuts the door.*)

MME PINCHARD: What was the matter, Pinchard?

PINCHARD: Nothing, nothing. (*Pushing her towards the bed.*) There, go to bed. It's late, I'm coming too. (*Aside.*) I really shut that beggar up. (*He takes off his jacket and hangs it up in the wardrobe without seeing MITZI. MITZI slowly closes the wardrobe. MME PINCHARD gets into bed. The bell rings.*) Damn! He's off again. It really is extremely tiresome! (*He sits on his side of the bed to take off his shoes. The bell on his side begins to ring.*) What! Now another one's started! It's unbelievable! Is there a bell-ringing competition in this hotel? I've never heard such a racket! (*He starts taking off a shoe, turning his back on the door to Room 38.*)

Scene 15

PINCHARD, MME PINCHARD, PONTAGNAC, LUCIENNE, then VICTOR, the MANAGER, CLARA, GUESTS etc.

LUCIENNE: (*Rushing in, followed by PONTAGNAC.*) Ah, got you, you wretch!

She rushes up to PINCHARD and grabs him by the shoulders. PINCHARD is knocked off balance and falls to the joor. He still has his back turned to them.

LUCIENNE and PONTAGNAC: (*To each other.*) It's not him!

They rush back into Room 38.

PINCHARD: (*Picks himself up, his shoe in his hand. He limps round the room shouting.*) Well, where are they? Where have they gone?

VICTOR: (*Knocking and rushing in.*) What's the matter, Monsieur? What's going on?

PINCHARD: (*Putting on a slipper.*) Eh?

CLARA: (*Knocking and rushing in.*) Is it you, Monsieur, ringing like that?

PINCHARD: Me?

MANAGER: (*Knocking and rushing in.*) Really, Monsieur, you must stop ringing like that. You'll wake the whole hotel.

PINCHARD: What? Am I the one who's ringing?

GUEST: (*Knocking and rushing in, wearing a dressing gown and night cap.*) Will you stop that confounded ringing, Monsieur! My wife can't sleep.

SECOND GUEST: (*Entering.*) Why are you ringing like that?

A series of GUESTS enter, in various stages of undress. General babble of protests.

GUEST: What's the matter? Why's he ringing?

PINCHARD: Really! Who the hell are all these people? Will you please get out of my room!

MANAGER: Yes. Once you've stopped ringing!

ALL: Yes! Yes!

PINCHARD: Oh I'm doing the ringing, am I? How? Where? Can anyone see me ringing? Or anyone else for that matter? Nobody's ringing in here.

MANAGER: Now come on, Monsieur.

PINCHARD: How dare you burst in on me like this? Get the hell out of here!

ALL: (*Shouting him down.*) Oh!

PINCHARD: (*Furious.*) Go on – bugger off! (*He emphasises each syllable by banging the mattress with his shoe.*

The bell responds with a short ring on each blow. PINCHARD stops, looks at the mattress, then deliberately hits it again three times. The bell responds accordingly.) Good God! It's the bed that's ringing.

ALL: The bed?

PINCHARD: Absolutely! (*He pulls the bell from under the mattress.*) Ah ha! Very funny! I'd like to lay my hands on the joker behind this prank.

ALL: (*Astonished.*) Oh!

PINCHARD: Hang on. I bet there's another one under my wife.

The MANAGER and the GUESTS search under the mattress for the other bell.

MME PINCHARD: (*Who hasn't understood a word, screams.*) Pinchard! Pinchard! These men are after me!

PINCHARD: It's not you they're after.

MANAGER: Don't be alarmed, Madame, (*Finding the bell.*) Ah, yes! Here's the other one.

PINCHARD: (*Taking the bell.*) There! What did I tell you? I'd like to know the meaning of all this?

MANAGER: But, Monsieur, I have simply no idea –

PINCHARD: (*Interrupting.*) If this is how you amuse yourselves at the expense of your guests, I shall make a complaint, I promise you.

MANAGER: Oh, Monsieur, I can assure you...

PINCHARD: (*Giving the bells to the MANAGER.*) Now clear off! Just get out, all of you, and leave us in peace! (*Everyone exits. He slams the door shut.*) Rum sort of barracks this is!

MME PINCHARD: (*Kneeling up in the bed.*) What is going on?

PINCHARD: (*Aside.*) She hasn't heard a thing! (*Aloud.*) Coco, you don't know your own luck.

MME PINCHARD: What did they want, all those people?

PINCHARD: (*Shaking his head.*) Nothing, nothing. (*He pulls off his other shoe.*)

MME PINCHARD: Oh, they frightened me! The pains were beginning to go. But now they're worse than ever. (*She cries hysterically.*)

PINCHARD: Oh, the brutes! Right! You'd better have a poultice.

MME PINCHARD: What?

PINCHARD: (*Mouthing.*) You'd better have a poultice.

MME PINCHARD: You're talking to me with your back to the light. I can't see a word you're saying!

PINCHARD: (*Picking up a candle and illuminating his face. Mouthing.*) You'd better have a poultice.

MME PINCHARD: Oh yes. With a few drops of laudanum. That would do me good.

PINCHARD: (*Mouthing.*) I just have to make it up. Hang on. (*He rings the bell, then opens the bag. Aside.*) I knew she was unwell before we set off. Thank God I made provision, just in case. Now, where's the linseed?

Scene 16

PINCHARD, MME PINCHARD, VICTOR, then MITZI, then VATELIN.

VICTOR: (*Entering with a grin.*) You rang, Monsieur?

PINCHARD: Yes. It was me this time. I want a bread poultice made up for Coco. I mean for Madame, who's poorly.

VICTOR: But, Monsieur, there's no-one in the kitchen now.

PINCHARD: Of course not! There were masses of people in here a moment ago, but now there's no-one at all in the kitchen! Right! You show me the way, and I'll make up the poultice myself.

VICTOR: Very good, Monsieur. Allow me, Major? (*He offers to help PINCHARD with his jacket.*)

PINCHARD: (*Giving him the jacket.*) No I won't allow you: I order you. (*Candle in hand, he mouths to his wife.*) I'm going downstairs to make up a poultice. I'll be back in five minutes. You're to try and get some sleep.

MME PINCHARD: (*Hysteria continuing.*) Try and get some sleep? If only I could! Don't be long!

PINCHARD: (*Shouting.*) No.

MME PINCHARD covers her face with the sheet. PINCHARD and VICTOR exit. The stage remains empty a moment. MITZI enters.

MITZI: (*Aside.*) The noise has stopped. What has been going on? And Vatelin hasn't come back. Oh no, no, no. I'm going to get dressed and get out of here… But where's he hidden my clothes? (*Searches around by the bed. She catches sight of MME PINCHARD in the bed.*) Um Gottes willen! There's someone in the bed! (*Terrified, she rushes back into the bathroom.*)

The stage is empty for a moment. The noise of a key turning in the lock and someone trying the door.

VATELIN's VOICE: Damn! What's wrong with this lock?

The key is heard again in the lock. VATELIN pushes the door open.

(*Aside.*) Silly ass! I was turning it the wrong way. I double locked it instead of opening it. (*He closes the door.*) Now let's get Mitzi out. (*Snoring from the bed.*) What was that? Someone just snored. (*Pulling the curtain out of the way.*) What? She's gone to bed? (*Taking his bag from behind the sofa, he puts it on the table and pulls out a pair of slippers which he throws down in front of the bed. Then he draws up a chair to the bed on which to put his clothes.*) She's asleep so don't let's wake her. What a piece of luck! I'll just get into bed extremely quietly… (*He trips over the shoes left by PINCHARD and picks them up.*) Good God, what enormous feet these Swiss women have! (*He takes off his shoes and goes to put them outside the door with PINCHARD's.*) Lord, I'm thirsty. (*Seeing the glass that PINCHARD has left on the table.*) Ah! Just what I needed. (*He drinks and finishes undressing.*) I can hardly keep my eyes open… I don't think I'll be long dropping off… Come on… into bed… gently does it. (*He slips into bed.*) I'm so sleepy… much more so since I had that drink… What can she have put in it? Strychnine again, I suppose. Strychnine…! (*He falls asleep, horrified at the thought.*)

Scene 17

VATELIN, MME PINCHARD, MITZI, PINCHARD, VICTOR, then LUCIENNE, PONTAGNAC.

The door opens. VICTOR shows in PINCHARD holding his poultice.

PINCHARD: Thank you. (*VICTOR exits. PINCHARD blows on the poultice and sprinkles landanum on it. He moves towards the bed.*) There you are, Coco. Take care, it's hot!

He pulls up the covers with his right hand. With his left he applies the poultice to VATELIN's stomach.

VATELIN: (*Shrieking and springing up.*) Aaaah!

PINCHARD: What the devil's this?

VATELIN: Who's there? Stop thief!

PINCHARD: (*Opening the door to the corridor.*) A man in my wife's bed!

MME PINCHARD: (*Waking up.*) Who's there? Oh, my God! A man in my bed!

VATELIN: Who the hell are you?

PINCHARD: (*Seizing him by the throat.*) Scoundrel! What are you doing there?

VATELIN: (*Getting out of bed.*) Will you let go of me!

ALL: Help! Help!

PINCHARD: (*Shouting at the open door.*) There's a man in my wife's bed!

VATELIN: Let me go! (*He jumps on the bed.*)

LUCIENNE: (*Bursting into the room, followed by PONTAGNAC. She sees VATELIN crouched by MME PINCHARD on the bed.*) Ah, you brute!

VATELIN: (*Aside.*) Heavens! My wife! (*He covers himself with the bedspread, pushes PINCHARD away, scoops up the chair with his clothes on it and escapes, carrying the chair with him.*)

PINCHARD: (*To LUCIENNE.*) Madame, you're a witness. He was in Coco's bed.

LUCIENNE: I saw it all, Monsieur.

PINCHARD: (*Exiting in pursuit.*) Catch him! He was in my wife's bed!

MME PINCHARD: (*Gets out of bed and runs after him.*) Pinchard! Pinchard! Where are you going? (*She exits.*)

PONTAGNAC: Well, then! Convinced now are you?

LUCIENNE: Oh, yes! He's a traitor.

PONTAGNAC: And you know how to take your revenge?

LUCIENNE: Oh, I do. Indeed I do!

PONTAGNAC: Bravo! (*PONTAGNAC begins to losen his tie and take off his coat.*)

LUCIENNE: I said I would take a lover and I will.

PONTAGNAC: Ah! I'm the happiest of men!

LUCIENNE: And if my husband asks who my lover is, perhaps youd like to tell him!

PONTAGNAC: Oh… it's not worth the bother, surely.

LUCIENNE: It's his best friend! Ernest Rédillon. 17, Rue Caumartin.

PONTAGNAC: (*Choking.*) What? Rédillon?

LUCIENNE: Good-bye. I'm off to take my revenge! (*She exits into Room 38.*)

PONTAGNAC: Lucienne! In heaven's name! Lucienne! (*He rushes to the door. Aside.*) Locked!

Scene 18

PONTAGNAC, then MITZI, SOLDIGNAC, FIRST POLICE INSPECTOR, two OFFICERS, then MME PONTAGNAC, SECOND POLICE INSPECTOR, two more OFFICERS, then REDILLON.

PONTAGNAC runs upstage straight into the POLICE INSPECTOR who is just entering followed by his OFFICERS and SOLDIGNAC.

INSPECTOR: Stop! In the name of the law!

PONTAGNAC: (*Aside.*) The Inspector!

SOLDIGNAC: (*A billiard cue in his hand.*) Ah! Her liebling!

INSPECTOR: (*To PONTAGNAC.*) We know everything, Monsieur! You are here with this gentleman's wife!

PONTAGNAC: Me?

INSPECTOR: Where is your paramour hiding?

PONTAGNAC: My paramour?

INSPECTOR: Make a search.

PONTAGNAC: (*Aside.*) What's he talking about?

FIRST OFFICER: (*Returning from the bathroom, with MITZI.*) Here is Madame!

PONTAGNAC: (*Aside.*) Who on earth's that?

MITZI: (*Aside, seeing SOLDIGNAC.*) My husband!

SOLDIGNAC: (*Aside, seeing MITZI.*) My wife!

MITZI: Also, Narcisse, du sollst mir gar nichts sagen. Ich kann dir alles erklären. Bin gar kein hure. (*She hits her husband hard in the stomach.*)

SOLDIGNAC: Mitzi, was machst du hier also, du verfluchteste Frau? Betrogen hast du mich, das ist ganz klar. Abscheiden. Ich will abscheiden. (*He hits MITZI. She falls into PONTAGNAC's arms.*)

SECOND INSPECTOR: (*Entering, followed by MME PONTAGNAC.*) In the name of the law –

PONTAGNAC: (*Aside.*) Another Inspector. (*Seeing his wife.*) My wife!

MME PONTAGNAC: (*To the SECOND INSPECTOR.*) Do your duty, Inspector! (*She exits quickly.*)

PONTAGNAC: (*Running after her.*) Clothilde…!

SOLDIGNAC: (*Barring his way.*) Now it's between the two of us!

He punches PONTAGNAC. MITZI hits the OFFICER who is trying to restrain her. They all fight.

REDILLON: (*Entering, carrying MITZI's bag in his hand. They all stop fighting and stare at REDILLON.*) Well, well! What's going on here then? (*Seeing the INSPECTORS who are eyeing him.*) I beg your pardon. I took the wrong bag.

He gently exchanges his bag for VATELIN's and escapes. They all resume the fight. The two INSPECTORS are knocked out. PONTAGNAC tries to sneak out but his way is barred by the SOLDIGNACS who are still boxing.

End of Act Two.

ACT THREE

Scene 1

GEROME, then REDILLON, ARMANDINE.

REDILLON's study. Eleven o'clock in the morning. Light filters through the closed shutters. GEROME enters. He finds REDILLON's clothes and ARMANDINE's skirt scattered on the floor. He picks up the skirt.

GEROME: Another skirt! There's always another skirt! He's incorrigible! I wonder what he does with them all. That's young men today for you – burning the candle at both ends! Always on the move. Everyone's always on the move. Except me. Keeping on top of things, he calls it. (*He knocks at the bedroom door.*)

REDILLON's VOICE: What is it?

GEROME: It's me. Gérome.

REDILLON: (*Putting his head round*) Well, what is it?

GEROME: It's eleven o'clock in the morning.

REDILLON: So it's eleven o'clock in the morning. (*He slams the door shut in GEROME's face.*)

GEROME: Yes! (*Aside.*) Slammed in my face! See that? And I was there at his birth. No respect at all! And his father, on his deathbed, made me promise to take care of him... Take care of him... How can I take care of him? When I have to run round after the women he brings home. (*Voices in REDILLON's room. The door opens.*) Oh, they've decided to get up. (*GEROME exits.*)

ARMANDINE enters, followed by REDILLON. She is wrapped in a man's dressing gown. As she enters, she catches her foot and nearly falls.

ARMANDINE: Your dressing gown's too long.

REDILLON: Too long for you maybe. But not for me.

ARMANDINE: Yes, but I'm the one wearing it because I have nothing else. I mean, fancy bringing me, one after the other, all the bags in the hotel except my own.

REDILLON: How was I supposed to know which one was yours?

ARMANDINE: There were plenty to choose from. Surely you could have found mine.

REDILLON: (*Yawning.*) Ah! Well…

ARMANDINE: Well what?

REDILLON: Eh?

ARMANDINE: Are you feeling ill?

REDILLON: No! I'm tired, that's all!

GEROME enters, carrying a feather-duster. He looks pityingly at REDILLON.

ARMANDINE: After eleven hours in bed!

REDILLON: Four hours actual sleep. (*He yawns.*)

GEROME: How can anyone let themselves get in such a state?

REDILLON: What do you want, Gérome?

GEROME: Nothing.

REDILLON: Then why are looking at me like that?

GEROME: Oh, Ernest! You're wearing yourself out, my boy!

REDILLON and ARMANDINE: What?

GEROME: You're a worry to me.

REDILLON: Would you mind shutting up? Who asked your opinion anyway?

GEROME: I don't need to be asked. I'm telling you. You're a worry to me. (*He exits.*)

REDILLON: Ah well! I'm glad to hear it.

Scene 2

ARMANDINE, REDILLON.

REDILLON: I'm so sorry. He's an old retainer. Part of the family. His mother was Papa's wet-nurse. So we're milk rather than blood relations.

ARMANDINE: Really.

REDILLON: He's a sort of wet-uncle.

ARMANDINE: He's much more familiar with you than you are with him.

REDILLON: Well, so I should think. He was present at my birth. I wasn't at his. (*Yawning.*) Oh Lord, I'm so tired. (*He stretches out on the sofa.*)

ARMANDINE: Oh, my poor Ernest. Not exactly a record holder, are you? (*She goes over to him.*)

REDILLON: I didn't know we were trying for a medal.

ARMANDINE: (*Embracing REDILLON.*) You'll do all the same. (*She kisses him.*) My kisses seem to bore you!

REDILLON: (*Without conviction.*) No!

ARMANDINE: (*Sitting down.*) Yes, they do. Already.

REDILLON: No, no. But, look, after all… (*Imploringly.*) Let's have a rest!

ARMANDINE: Ah, that's typical! Men! They're only keen the night before. (*She gets up.*)

REDILLON: Or two days later!

ARMANDINE: (*Looking at a water-colour on the wall.*) This is nice. Does this house belong to you?

REDILLON: That? That's the Capitol in Rome.

ARMANDINE: I thought Rome was the capital. Oh! Darling! (*She embraces him.*)

Scene 3

ARMANDINE, REDILLON, GEROME.

GEROME enters with a glass of wine.

GEROME: Not again! I beg you, Madame, have pity.

ARMANDINE: Do you think there's something wrong with him?

GEROME: Just look at him!

REDILLON: I'm going to throw you out, you know!

GEROME: I don't care. I won't go. Here, drink this. (*GEROME breaks an egg into the glass of wine.*)

REDILLON: Oh, no.

GEROME: Drink it!

REDILLON: Oh! Really! I need the patience of a saint! (*He takes the glass.*)

ARMANDINE: What is that?

GEROME: An egg.

ARMANDINE: What?

GEROME: An egg in port wine. (*In a low voice.*) For pity's sake, Madame, remember that he's still a child. He's only thirty-two.

REDILLON: What are you whispering about?

GEROME: Nothing, nothing, nothing.

ARMANDINE: (*Teasing.*) We have our own little secrets.

GEROME: Nothing to do with you!

REDILLON: (*He drinks down the egg.*) Excuse me! Has anyone called?

GEROME: Oh, yes. First there was Pluplu.

ARMANDINE: Pluplu's been here?

GEROME: Yes. She was very insistent.

REDILLON: What did you say?

GEROME: That you'd got your mother here. She wanted to wait, so I told her that when you'd got your mother here, she usually stayed three or four days.

ARMANDINE: Well done. Thank you.

GEROME: And then Monsieur Mondor arrived.

ARMANDINE: Mondor? Wait now, Mondor, Mondor…

REDILLON: No, no, you wouldn't know him. He's too old for it!

ARMANDINE: Ah!

REDILLON: He's an antique dealer. His shop's in a flat across the landing. So sometimes, if he has a bargain…

GEROME: He's got something new to show you. A very rare piece, he said. A chastity belt.

REDILLON: Ah! Is that all?

GEROME: That's all. (*The doorbell rings.*) Don't move, I'll go.

REDILLON: I had no intention of going. If it's a lady, I'm not here.

GEROME: No need to tell me that! (*He exits.*)

ARMANDINE: Yes, we're not here! It might be Pluplu again and there'd be a scene. Not for me... I don't like violence. (*She runs towards the bedroom.*)

REDILLON: Where are you going?

ARMANDINE: I must get dressed. And if it is her, good-bye! I'm off!

Scene 4

REDILLON, GEROME, then LUCIENNE.

GEROME's VOICE: No, Madame, he's not at home! Yes, I'm quite sure. (*Putting his head round the door.*) It's another one. Get lost!

REDILLON: Let's go.

REDILLON and ARMANDINE exit to the bedroom.

GEROME: (*Opening the door.*) There, Madame, see for yourself, if you don't believe me.

LUCIENNE: (*Entering.*) Nobody!

GEROME: I tell you he isn't here.

LUCIENNE: Indeed! Say it's Madame Vatelin who wishes to speak to him.

GEROME: Madame Vatelin! The wife of Monsieur Vatelin? The friend he visits so often?

LUCIENNE: Exactly.

GEROME: Oh, then that's quite different! I beg your pardon, Madame. I took you for a tart!

LUCIENNE: Eh?

GEROME: (*Shouting at the bedroom door.*) Ernest! It's Madame Vatelin!

REDILLON's VOICE: What did you say?

GEROME: It's Madame Vatelin! (*To LUCIENNE.*) Here he is.

REDILLON: (*Rushing in, now in his dressing gown.*) It's not possible! You! Here. In my home! How?

LUCIENNE: Does that surprise you? Ah well... me too!

REDILLON: (*To GEROME.*) Tell the person in there that I'm sorry I won't be back because some important business has come up. (*Lowering his voice.*) Make up what you like. And once she's finished dressing, show her out.

GEROME: Understood. (*He knocks on the bedroom door.*)

ARMANDINE's VOICE: Don't come in!

GEROME: Right you are! (*He goes in.*)

Scene 5

LUCIENNE, REDILLON, then GEROME, ARMANDINE.

REDILLON: You! You, here!

LUCIENNE: Yes, me...! You must have heard?

REDILLON: No!

LUCIENNE: What! Well as I'm here, you should be able to guess.

REDILLON: What?

LUCIENNE: Last night I caught my husband 'in flagrante delicto'. Committing adultery.

REDILLON: No...! My God! So you've come here to make love with me!

LUCIENNE: I always keep my word!

A pause. REDILLON realises the implications.

REDILLON: Ah! Lucienne! I'm so happy! Do what ever you like with me! Take me! I am yours!

LUCIENNE: No, excuse me. I should be saying that to you.

REDILLON: That's what I meant.

GEROME: (*Entering from the bedroom.*) Psst!

REDILLON: What?

GEROME signals REDILLON to get out of the way. Then he returns to the bedroom.

REDILLON: Good!

LUCIENNE: What is it?

REDILLON: Someone passing through! Look, hide behind me. There's no point in you being seen.

LUCIENNE hides behind REDILLON, who spreads out his dressing gown to hide her. GEROME enters from the bedroom with ARMANDINE hiding behind him. They exit.

LUCIENNE: Alright?

REDILLON: Ssh! Wait! (*GEROME reappears and signals that ARMANDINE has left.*) Yes? (*GEROME nods and winks, then exits.*) Alright, they've gone.

LUCIENNE: Ah! (*She leaves her hiding place.*)

Scene 6

LUCIENNE, REDILLON, then GEROME.

REDILLON: Do sit down!

LUCIENNE: No, no! Can you believe it? The wretch!

REDILLON: Who?

LUCIENNE: Who? What do you mean, who? My husband, of course!

REDILLON: Ah, yes, yes. How silly of me! I was miles away.

LUCIENNE: And I was such a faithful wife. I always spurned the advances of poor Rédillon.

REDILLON: Yes, poor Rédillon!

LUCIENNE: Well, not any more. He loves me. I will be his. That is my revenge!

REDILLON: Yes! Oh, Lucienne! My Lucienne!

GEROME: (*Putting his head round the door.*) I'm just going out for a couple of pork cutlets. (*He exits.*)

REDILLON: (*Irritably.*) Eh? Alright! Alright! Coming in here to talk about cutlets... Oh, Lucienne! (*Suddenly running to the door.*) Oh, and some runner beans! Alright? Runner beans!

GEROME's VOICE: Alright.

REDILLON: He has a thing about giving me potatoes everyday. I'm sick of them... I'm so sorry. He's an old retainer – part of the family – rather down to earth. Not like us, floating blissfully on an ethereal plane...

LUCIENNE: I'm not floating blissfully on an ethereal plane!

REDILLON: No. What was I saying?

LUCIENNE: You were saying he makes you eat potatoes.

REDILLON: No. Before that?

LUCIENNE: You were saying, 'Oh Lucienne, Lucienne'.

REDILLON: (*Trying to remember what he had been saying*) Oh, Lucienne, Lucienne…! Ah, yes! (*Starting again.*) Oh, Lucienne, Lucienne! Tell me I'm not being toyed with in some dream! Are you really mine? Only mine?

LUCIENNE: Yes, really yours. Only yours!

REDILLON: Oh, I'm so happy!

LUCIENNE: Good! Well, that's some compensation. One person's misery may sometimes bring a little happiness to another.

REDILLON: Ah yes! Yes. Here, lean your head against my chest.

LUCIENNE: Hang on, my hat's getting in the way. (*She takes it off.*)

REDILLON: (*Taking it.*) Give it to me! (*He places it on his right fist while putting his left arm round LUCIENNE's waist.*) I'm intoxicated by the scent of your hair. Oh, just to feel you so close to me. Mine, all mine! (*He closes his eyes in delight.*)

LUCIENNE: Are you going to hold my hat like that all the time?

REDILLON: No. Wait. (*He tries to find the energy to walk across the room with the hat. He pushes it under the sofa instead. Kissing her.*) Ah! This is the first time my lips have been allowed to caress your skin.

LUCIENNE: It is. So now let us take our revenge!

REDILLON: Oh, yes!

LUCIENNE: Avenge me!

REDILLON: Oh, yes! Yes!

LUCIENNE: I loved that man. I gave him everything. My heart, my trust. And the chastity of a young girl.

REDILLON: Oh, no, no! Listen! Don't talk about your husband. Not just now. Don't let him come between us. Oh, my beloved Lucienne! (*They roll off the sofa onto the floor.*)

GEROME: (*Putting his head round the door.*) I'm home!

REDILLON: Don't come in!

GEROME: Alright. (*He enters.*) What are you doing down there?

REDILLON: None of your business. Go away!

GEROME: Right.

REDILLON: And shut the door behind you!

GEROME: Why? Are you cold?

REDILLON: Because I say so. And don't come in again unless I call.

GEROME: (*He moves towards the door.*) I couldn't find any runner beans.

REDILLON: I don't care!

GEROME: So I got potatoes. (*He exits.*)

REDILLON: I'm so sorry! He's an old retainer, part of the family. He rather takes things for granted. Now... (*Still on the floor.*) Oh, Lucienne, let me take you in my arms!

LUCIENNE: You do love me, don't you?

REDILLON: Do I love you? No. Just a moment. I'm not quite comfortable like this. Not close enough. Make a little room for me beside you. (*He sits down on the sofa.*) That's it! Ah, this way I can hold you closer to my heart!

He stretches behind her on the sofa and dozes.

LUCIENNE: So the prediction was right.

REDILLON: (*His eyes half-closed.*) What prediction?

LUCIENNE: A fortune-teller said I'd have two romantic adventures in my life. One at thirty-four, the other at sixty-six. Well, the first one has come true. I was thirty-four last week.

REDILLON: Hang on. No, like this! (*He stretches out with his head on LUCIENNE's lap.*)

LUCIENNE: What are you doing?

REDILLON: There. That's better. I can see you better! Hold you better! (*He kisses her.*) Ah, Lucienne, Lucienne!

LUCIENNE: (*Sighing.*) Ah!

REDILLON falls asleep. A pause.

LUCIENNE: Well?

REDILLON: (*Stirring.*) Well, what?

LUCIENNE: Is that all?

REDILLON: (*Waking up.*) What do you mean, is that all? Oh, Lucienne, Lucienne…!

LUCIENNE: (*Beginning to get angry.*) Well what? Lucienne, Lucienne! Can't you say anything else?

REDILLON: (*Sitting up.*) Lucienne, I don't know if it's the excitement… or the emotion… but I swear this is the first time this has ever happened to me.

LUCIENNE: Oh! You told me that you loved me.

REDILLON: But I do. I do love you. Only understand that I never ever expected... such happiness... such joy... I'm overjoyed! That's the trouble! Then add to that my scruples – the scruples of a decent man. They won't last... but they have some justification nonetheless.

LUCIENNE: It's a little late in the day for scruples, my friend.

REDILLON: No, no, they'll pass, I tell you. But just give me a moment to reflect. Come back tomorrow! Come back tonight!

LUCIENNE: Tomorrow! Tonight! That's out of the question. My husband will be here at any moment.

REDILLON: What?

LUCIENNE: I must have taken my revenge by the time he walks through the door.

REDILLON: Your husband? Your husband? Here at any moment?

LUCIENNE: Yes. I left him a note. 'You have deceived me, so I'm going to deceive you. If you don't believe me, come to your friend Rédillon's at noon. (*She looks at REDILLON.*) You will find me in the arms of my lover!'

REDILLON: No! This is madness! Oh my God! It's funny, I had a feeling... And we were just about to get down to it. Thank heaven I had the strength to be sensible.

Scene 7

REDILLON, LUCIENNE, then MME PONTAGNAC, GEROME

GEROME's VOICE: (*Outside the door.*) But no, Madame, you can't!

MME PONTAGNAC's VOICE: Yes I can. I tell you, I must!

REDILLON: Oh really! What is it now?

MME PONTAGNAC: (*Pushing past GEROME.*) Let me pass! (*She enters.*)

REDILLON and LUCIENNE: Madame Pontagnac!

MME PONTAGNAC: That's right. It's me! Ah ha, you didn't expect to see me so soon, did you? Yesterday, Monsieur Rédillon, I told you that if ever I had proof of my husband's infidelity, I'd come to you and say, 'Avenge me, I'm yours!'

LUCIENNE: Eh?

MME PONTAGNAC: (*Taking off her jacket and throwing it on the sofa.*) Well, Monsieur Rédillon, here I am! Avenge me, I'm yours!

REDILLON: Her as well!

LUCIENNE: I beg your pardon?

REDILLON: (*Aside.*) Oh, I'm fed up. My God! I'm fed up to the back teeth! Ah, no, no. Really!

LUCIENNE: Forgive me, Madame, but 'Avenge me, I'm yours…?' Aren't you being a little forward?

MME PONTAGNAC: I don't know what you mean, Madame. It's all been agreed with Monsieur Rédillon.

LUCIENNE: Oh, but forgive me, Madame. I was here first!

MME PONTAGNAC: That may be, Madame. But I must remind you that I booked Monsieur Rédillon yesterday.

LUCIENNE: You booked him? Well, I don't give a damn.

MME PONTAGNAC: Madame!

LUCIENNE: Madame!

REDILLON: (*Coming between them.*) Now look here, dammit. Where do I come into all this?

LUCIENNE: Alright! Speak up then.

MME PONTAGNAC: Go on. Have your say.

REDILLON: I intend to. This is quite astonishing, I must say! You both want revenge on your husbands… So I have to… Really! What do you take me for? A professional? To be hired out in games of conjugal tit for tat?

LUCIENNE: Oh, come along! Which of us is it to be?

MME PONTAGNAC: Yes.

REDILLON: Right. Neither of you. So there!

LUCIENNE and MME PONTAGNAC: Eh?

REDILLON: Good-bye.

LUCIENNE and MME PONTAGNAC: Oh!

GEROME: (*Rushing in.*) Guess what! Pluplu!

REDILLON: What about Pluplu?

GEROME: She's here again. She wants to see you.

REDILLON: What? Not Pluplu too? Oh no, no. Really! I've had enough. Tell her I'm not in. Tell her I'm dead!

GEROME: Right!

LUCIENNE and MME PONTAGNAC: Rédillon! Monsieur Rédillon!

REDILLON: No!

REDILLON exits into the bedroom and slams the door.
LUCIENNE and MME PONTAGNAC rush to it.

LUCIENNE and MME PONTAGNAC: Locked!

MME PONTAGNAC: There, Madame. You see what you've done.

LUCIENNE: Excuse me, Madame. It was you!

MME PONTAGNAC: So it's my fault! I'd just like you to know, Madame, that I find this situation extremely distressing.

LUCIENNE: You don't suppose, Madame, that I am here for pleasure.

MME PONTAGNAC: If only I weren't driven by revenge.

LUCIENNE: Oh! Me too!

MME PONTAGNAC: Is that all you can say? Oh! Me too?

LUCIENNE: What more can I say? We're both in the same situation.

MME PONTAGNAC: Yes. We've both been humiliated by our husbands.

LUCIENNE: Life is hard for faithful wives!

Scene 8

LUCIENNE, MME PONTAGNAC, GEROME, then PONTAGNAC.

GEROME: (*Entering.*) There's a young man asking for Madame Vatelin!

LUCIENNE: A young man? Asking for me? Who is he?

GEROME: Monsieur Pontagnac!

MME PONTAGNAC: My husband!

LUCIENNE: Is that what you call a young man?

GEROME: He's young to me. Remember, Madame, I was fully grown when Ernest was still at the breast.

MME PONTAGNAC: But what does he want?

LUCIENNE: I don't know. Why is he asking for me? Anyway, he's come at the right moment. I'm a man short for my revenge.

MME PONTAGNAC: What? You don't mean?

LUCIENNE: Oh, don't worry. It's only to pay my husband back.

MME PONTAGNAC: Oh, I see!

LUCIENNE: Will you lend me Monsieur Pontagnac?

MME PONTAGNAC: Of course. It will give me something else to hold against him.

LUCIENNE: Good! Here, Madame. You go in there, please. (*She shows her out through a side door.*) And you may show in Monsieur Pontagnac.

GEROME: Yes, Madame. (*PONTAGNAC rushes in as GEROME exits.*)

PONTAGNAC: Alone!

LUCIENNE: Was it you asking for me?

PONTAGNAC: Yes, me. Have you been here long?

LUCIENNE: I've just arrived.

PONTAGNAC: And Rédillon?

LUCIENNE: I'm still waiting for him.

PONTAGNAC: Thank God! I've arrived in time.

LUCIENNE: What do you mean by pursuing me here? What do you want?

PONTAGNAC: What do I want? I want to stop you doing something insane. I want to throw myself between you and Rédillon. Fight for you. Tear you away from him.

LUCIENNE: You! By what right?

PONTAGNAC: By what right? The right given by all the troubles that have rained on my head since yesterday! My love for you has got me into the most appalling mess! I'm up for two cases of adultery which I didn't commit! Caught by a husband I don't know with a woman I don't know! Caught by my own wife with the same woman I don't know! My own divorce pending. Another divorce between the woman I don't know and the husband I don't know in which I'll be cited as co-respondent...! A terrible row with Madame Pontagnac... The woman I don't know arrives this morning to tell me in a Swiss accent that I owe her reparation. A dispute with the husband I don't know complicated by assault and battery. Turmoil, law suits, scandal! Have I incurred all this, the whole lot, everything... for you to throw yourself into the arms of another man? Is he to play cock of the walk while I'm left an absolute turkey...? Oh, no, no, you couldn't want that! (*He breaks down.*)

LUCIENNE: (*Aside.*) Couldn't I? (*Aloud.*) Well, well... It's funny how things turn out. Seeing you arrive just now, I said to myself – thinking of my revenge – 'Why Rédillon? After all, it was Monsieur Pontagnac who pointed out my husband's infidelity.'

PONTAGNAC: Absolutely!

LUCIENNE: If anyone has a right to avenge me, it's him!

PONTAGNAC: No! Are you serious?

LUCIENNE: So if I were to ask you…

PONTAGNAC: If you were to ask me…! You know very well that I'd be the happiest of men!

LUCIENNE: Yes…? Very well. Be the happiest of men! Monsieur Pontagnac, you shall be my avenger!

PONTAGNAC: No!

LUCIENNE: Yes!

PONTAGNAC: I can't believe it! (*Aside.*) And here, in Rédillon's place. How exquisite! (*He locks the door at the back and then closes the shutters.*)

LUCIENNE: Well, come on! (*She takes off the top half of her costume to reveal an extremely décolleté bodice underneath. At the same time, she unpins her hair and shakes it loose.*) My husband found me most beautiful like this. Am I really beautiful like this?

PONTAGNAC: Oh yes! Beautiful! Beautiful! Like a princess in the Arabian Nights.

LUCIENNE: I re-read it this very morning.

PONTAGNAC: Why?

LUCIENNE: Why? Because…! Because I'm new to this sort of revenge and I wanted to get it right. (*Changing her tone.*) You do love me?

PONTAGNAC: (*Taking her in his arms.*) Profoundly!

LUCIENNE: (*Aside.*) I'd say he knew the text off by heart! (*Aloud.*) And you'll be mine always?

PONTAGNAC: For all eternity!

LUCIENNE: Good. Now do go and sit down.

PONTAGNAC: (*Astonished.*) What do you mean? Go and sit down!

LUCIENNE: Just that.

PONTAGNAC: But I thought…

LUCIENNE: Yes, I know. But perhaps I don't want to right now, just like that. Perhaps I want to choose my moment, the moment when I'm to be desired. The man who makes love to me must be a slave to my every whim. I said, sit down. Sit down!

PONTAGNAC: Yes! (*He sits down.*)

LUCIENNE: Good!

PONTAGNAC: I've obeyed you.

LUCIENNE: Very good. Take off your jacket.

PONTAGNAC: I beg your pardon?

LUCIENNE: Take off your jacket. I can't bear to see you with it on. You remind me of my husband.

PONTAGNAC: Oh, well then. Only I warn you that, underneath, I'm in shirtsleeves.

LUCIENNE: It doesn't matter.

PONTAGNAC: Right! (*He takes off his jacket.*) And now?

LUCIENNE: Sit down there. Next to me.

PONTAGNAC: (*Sitting down.*) There!

LUCIENNE: Good.

PONTAGNAC: (*After a moment.*) Well? What are we waiting for now?

LUCIENNE: My pleasure.

PONTAGNAC: Ah!

LUCIENNE: Take off your waistcoat! You look like a removal man.

PONTAGNAC: What? You want…?

LUCIENNE: Please. (*PONTAGNAC rises.*) And sit down.

PONTAGNAC: (*He sits. Then takes off his waistcoat and throws it to one side.*) Alright. As you've ordered me. You don't think I look ridiculous like this?

LUCIENNE: Never mind! (*She unbuttons one of his braces.*) They're so ugly. Like your hair. Who cuts your hair like that? You look like a head waiter.

PONTAGNAC: (*Who has unbuttoned the other brace.*) Oh!

LUCIENNE: Turn round. (*Ruffling his hair.*) There! Now at least you look artistic!

PONTAGNAC: Oh, do you think so…? Ah Lucienne, my Lucienne!

He pulls her on top of him.

LUCIENNE: What is it?

PONTAGNAC: Oh, sorry!

LUCIENNE: Do please behave yourself when there's nobody here!

PONTAGNAC: What do you expect? I'm not made of –

LUCIENNE: Alright! That's enough.

PONTAGNAC: Yes.

LUCIENNE rises and picks up a newspaper from a table. She sits down, and starts to look through it.

PONTAGNAC: (*Aside.*) What a funny way to go about making love!

LUCIENNE: (*After a pause.*) Ah-ha! There's a première tonight at the Comédie Française.

PONTAGNAC: Ah-ha!

LUCIENNE: Are you going?

PONTAGNAC: No.

LUCIENNE: Ah…!

She begins to read. PONTAGNAC, not knowing what to do, rises.

LUCIENNE: (*Without raising her head.*) Sit down!

PONTAGNAC: Oh, alright. (*He sits down obediently.*) But what do I have to do…? Do I have to beg to get the honey?

Voices offstage.

LUCIENNE: Sssh!

PONTAGNAC: What is it?

LUCIENNE: (*Aside.*) At last…! (*Aloud.*) Who knows? Some people… Perhaps my husband…

PONTAGNAC: Your husband!

LUCIENNE: With any luck! It will make my vengeance complete!

Scene 9

LUCIENNE, PONTAGNAC, then VATELIN, INSPECTOR, two POLICEMEN, then REDILLON, then MADAME PONTAGNAC, then GEROME.

INSPECTOR's VOICE: Open up in the name of the law!

PONTAGNAC: It's them! Hide!

LUCIENNE: Why should I hide? Don't you love me enough to fight my husband for me?

PONTAGNAC: Of course, but…

INSPECTOR's VOICE: Will you please open up!

LUCIENNE: Very well. I wish to be yours – in front of all of them! Take me, Pontagnac, I'm yours! Yours!

PONTAGNAC: What? You mean now?

LUCIENNE: Now or never!

PONTAGNAC: (*Moving away.*) Oh, no, no. Really!

INSPECTOR's VOICE: Open up, or I'll break down the door.

LUCIENNE: Very well! Break down the door.

The door is forced open. LUCIENNE pulls PONTAGNAC on to the sofa and lies in his arms. She stares defiantly at her husband.

VATELIN: (*Entering.*) Oh, you wretched woman!

INSPECTOR: (*Entering with two POLICEMEN.*) Nobody move.

VATELIN: So it's true!

PONTAGNAC: (*To the INSPECTOR.*) Now look here…

INSPECTOR: (*Seeing him.*) Not you again, Monsieur! This is becoming a habit.

PONTAGNAC: But, Monsieur, I don't understand. I was just making a social call on Madame.

INSPECTOR: Dressed like that? Put your clothes on, Monsieur!

PONTAGNAC collects his clothes, unseen by REDILLON, who enters from the bedroom.

REDILLON: Well! What on earth's going on?

INSPECTOR: Madame, I am the police inspector of this district. I'm here at the request of your husband, Monsieur Crépin Vatelin –

REDILLON: No! I must interrupt. Adultery? In my house? (*Aside, as he notices PONTAGNAC.*) Pontagnac!

LUCIENNE: (*Still in her pose on the sofa.*) It's alright, Inspector, I know the speech. I'll make your job easier. Monsieur Pontagnac may say what he likes to try and save me. That is his duty as a gentleman. But I intend you all to know the truth! (*She looks defiantly at VATELIN.*) I came here of my own free will and for my own pleasure. I came to meet Monsieur Pontagnac. My lover!

VATELIN: She admits it!

LUCIENNE: Inspector, I authorise you to include this confession in the official report.

VATELIN: Oh!

MME PONTAGNAC: (*Aside, appearing at the side door.*) My turn now!

PONTAGNAC: (*Aside.*) My wife!

MME PONTAGNAC: Inspector, please enter on the record as well that I, Clothilde Pontagnac, Monsieur's lawful wife, was found by you in this house where, like Madame, I'd come to meet my lover.

PONTAGNAC: What did she say?

MME PONTAGNAC: Good-bye, Monsieur! (*She exits.*)

PONTAGNAC: (*Running after her, his braces flapping.*) Wretched woman!

INSPECTOR: (*Stopping him.*) Please remain here, Monsieur. We need you.

PONTAGNAC: But, Inspector, you heard what she said. She has a lover. Where is the scoundrel? I'll strangle him. I'll kill him!

GEROME enters.

GEROME: (*Aside.*) He wants to hurt Ernest, my baby!

PONTAGNAC: Just let him show himself, this lover! (*Glaring at REDILLON.*) If he's not a coward!

GEROME: It's me.

PONTAGNAC: You!

REDILLON: (*To GEROME.*) Really. What are you saying?

GEROME: (*To REDILLON.*) Shut up, I'm saving you.

PONTAGNAC: Very well, Monsieur, we shall meet again. Your card!

GEROME: I don't have a card. I'm the valet to Monsieur. My little Ernest.

PONTAGNAC: A valet! (*Aside.*) Oh no! (*He collapses with the indignity.*)

INSPECTOR: Now then. Can't you see they're all making a fool of you? Even Madame Pontagnac? Don't you understand that these are the antics of an injured woman, not a guilty wife?

PONTAGNAC: I shall find out!

INSPECTOR: In the meantime, we need you here. Where can I write my report?

REDILLON: Through there, Inspector. (*He shows him out.*)

INSPECTOR: Thank you, Monsieur. (*To PONTAGNAC.*) Be so good as to follow me, Monsieur. And you, Madame.

LUCIENNE: By all means. (*She gets up, suppressing her emotion with difficulty. VATELIN looks at LUCIENNE. She immediately resumes her air of bravado.*) Let's go! (*She, PONTAGNAC and the INSPECTOR exit.*)

Scene 10

VATELIN, REDILLON, then LUCIENNE, then INSPECTOR, then PONTAGNAC, POLICEMEN, then GEROME.

REDILLON: (*Laughs.*) Well! What a terrible mess! (*VATELIN collapses.*) I say, come along now, Vatelin. Take a grip.

VATELIN: Oh, my friend, it's dreadful what I'm suffering! It's here… Boom, boom, boom! (*He beats his forehead.*)

REDILLON: Come along. You'll get over it.

VATELIN: Get over it? I wouldn't mind if someone else's wife were involved. But just imagine being married and then deceived by your own lawful wife. It's unbearable!

REDILLON: Vatelin, may I say something to you as a friend?

VATELIN: My dear chap, of course!

REDILLON: Well, Vatelin my friend, you're a fool.

VATELIN: Do you think so?

REDILLON: Absolutely.

VATELIN: A fool who's a cuckold then!

REDILLON: No, no. A fool precisely because you think you're a cuckold. Now, look. The mere fact that she wrote to you, 'Come to Rédillon's where you'll find me in the arms of my lover', must have

alerted you surely. A woman who's deceiving her husband doesn't normally send him an invitation.

VATELIN: That's true. But then?

REDILLON: Then she must have had a reason. And it was to make her husband jealous! Everything points to it. This show of accusing herself.

VATELIN: Yes!

REDILLON: This assignation…

VATELIN: Yes!

REDILLON: The tart's get-up…

VATELIN: Yes!

REDILLON: The casting of Pontagnac whom she only met yesterday…

VATELIN: Yes!

REDILLON: I happen to know something about it because she came here to offer me the part. Which I refused. (*Aside.*) With good reason!

VATELIN: Oh, my friend! My friend!

REDILLON: And you fell straight into the trap. Not much of a tactician, eh?

VATELIN: I'm a lawyer.

REDILLON: Well, there you are.

VATELIN: Oh, I'm so happy! (*Sobbing.*) So ha…ha… hap…py! Oh, oh, oh, oh, oh! (*He weeps.*)

REDILLON: Really! You look it!

The door at the back opens and LUCIENNE enters. She looks questioningly at REDILLON who signals her to be quiet and listen. She stands behind VATELIN.

VATELIN: Oh how happy I am! How happy I am!

REDILLON: Yes, well, don't overdo it.

VATELIN: Oh my friend, be a good chap. Find my wife and tell her I love only her. Make her believe it's the truth – that in me she has the most faithful of husbands.

REDILLON: After your little escapade last night?

VATELIN: My little escapade last night! Do you think that was for fun? You should have been there.

REDILLON: I think I might have been 'de trop'.

VATELIN: No, you should have come. Oh my God, that woman…! And those feet! You should've seen the size of her boots! And the irony is, apart from that one indiscretion, I have never – I know you'll find it hard to believe – I have never been unfaithful to my wife. One little incident in Zürich. Away for a month. No wife. I'm not made of wood. I thought it was all over. I did, really. But yesterday she tracked me down in my own home and she threatened me with scandal. I was afraid of distressing my wife, so I gave in.

REDILLON: What a pity your wife can't hear you now! (*He looks at LUCIENNE*)

VATELIN: Oh, yes, what a pity. I know I could convince her. I know she'd believe me. She'd see so much love in my eyes that she wouldn't have the heart to reject me. I'd hold out my hand to her. She'd put her little hand in mine and I'd hear her beloved voice say, 'I forgive you, my Crépin!'

REDILLON takes LUCIENNE's hand and puts it in VATELIN's.

LUCIENNE: I forgive you, my Crépin.

VATELIN: (*Getting up.*) You! Oh, you wicked girl. How you've made me suffer!

LUCIENNE: What about you...?

VATELIN: I adore you. (*He falls sobbing into her arms.*)

LUCIENNE: My darling!

REDILLON: I love you both!

VATELIN: My dear friend! (*All three embrace each other and weep. To LUCIENNE.*) Oh, he's been so good, you know.

INSPECTOR: (*Entering.*) The official report is complete, if you'd care to read it through.

VATELIN: Official report! There is no official report! There's no longer any reason for an official report! Tear up the official report!

INSPECTOR: What?

VATELIN: Come along, Inspector. We'll go and tear up the official report together.

INSPECTOR: You're more changeable than the weather. (*They exit.*)

REDILLON: Well.

LUCIENNE: Well?

REDILLON: Forgiven?

LUCIENNE: Forgiven!

REDILLON: And for me, it's all over?

LUCIENNE: All over. But you know what the fortune-teller said: I would have two adventures in my life. Well, the first one's gone and the second's due at sixty-six. If that tempts you?

REDILLON: Hmm! At sixty-six?

LUCIENNE: Well! Really!

REDILLON: Oh! No! You'll always be charming. But by then I may be rather worn out.

LUCIENNE: (*Mocking.*) I see. Much like this morning.

VATELIN and PONTAGNAC enter with POLICEMEN, who exit via the main door.

VATELIN: Thank you, Inspector. There. That's done. As for you, Pontagnac, I should be cross with you, but I've no hard feelings. And to prove it – I give a little dinner party every Monday: would you care to be one of my regulars?

PONTAGNAC: Me! What? Really…? Thank you!

VATELIN: Men only!

PONTAGNAC: Oh!

VATELIN: It's the day my wife dines with her mother.

PONTAGNAC: Oh, with pleasure! (*Aside.*) No, thanks!

REDILLON: (*Quietly to LUCIENNE.*) All the same, if the fancy takes you again some time, just give me a day's notice, will you?.

GEROME: (*Entering.*) Am I supposed to give you all lunch?

REDILLON: Yes, of course!

ALL: We'd be delighted.

REDILLON: (*As he exits.*) I hope you like potatoes.

They all leave except PONTAGNAC.

PONTAGNAC: (*Shutting the door after them.*) No! I'm not going to be the turkey at this feast. Absolutely not!

He runs to the main door and exits.

Curtain.